TATION MOVEMENT
Three Installations, Two Films

TATION MOVEMENT
Three Installations, Two Films

Paul McCarthy

CENTRAL SYMMETRICAL ROTATION MOVEMENT
Three Installations, Two Films
Chrissie Iles

Whitney Museum of American Art, New York
Distributed by Yale University Press, New Haven and London

This catalogue was published on the occasion of the exhibition *Paul McCarthy: Central Symmetrical Rotation Movement—Three Installations, Two Films*, at the Whitney Museum of American Art, New York, curated by Chrissie Iles, Anne and Joel Ehrenkranz Curator, with the assistance of Gary Carrion-Murayari, curatorial assistant.

Whitney Museum of American Art, New York, June 26–October 12, 2008

Major support for this exhibition is provided by the National Committee of the Whitney Museum of American Art in honor of Linda Pace. Generous support is provided by Warren and Allison Kanders. Significant support for the catalogue is provided by Hauser & Wirth London/Zurich.

This publication was produced by the Publications Department at the Whitney Museum of American Art, New York: Rachel de W. Wixom, head of publications; Beth A. Huseman, editor; Beth Turk, assistant editor; Anna Knoell, designer; Vickie Leung, production manager; Anita Duquette, rights and reproductions manager; Berit Potter, rights and reproductions assistant; Jessa Farkas, rights and reproductions assistant; and Adam Welch, publications assistant.

WHITNEY

Whitney Museum of American Art
945 Madison Avenue
New York, NY 10021
whitney.org

Edited by Beth A. Huseman
Copyedited by Sharon Vonash
Design and production by Garrick Gott
Printed by Capital Offset Company

Set in Avant Garde Gothic, Neuzeit Office, and Courier
Printed on PhoeniXmotion Xantur and Mohawk Via Vellum

Library of Congress Cataloging-in-Publication Data
Iles, Chrissie.
 Paul McCarthy : central symmetrical rotation movement : three installations, two films / Chrissie Iles.
 p. cm.
 Catalog of an exhibition at the Whitney Museum of American Art, New York, June 26–Oct. 12, 2008.
 Includes bibliographical references.
 ISBN 978-0-300-14138-2
 1. McCarthy, Paul, 1945—Exhibitions. 2. Installations (Art)—United States—Exhibitions. 3. Video art—United States—Exhibitions.
I. McCarthy, Paul, 1945- II. Whitney Museum of American Art. III. Title.
N6537.M39626A4 2008
778.59—dc22
2008020238

Yale University Press
302 Temple Street
P.O. Box 209040
New Haven, CT 06520
yalebooks.com

Cover and title page: detail of *Inverted Rooms and Hallways*, 1970. Page 5: *Upside Down Chair*, 1971. Wood, chair, rope, and building, dimensions variable. Courtesy the artist and Hauser & Wirth London/Zurich. Page 11: detail of *Spinning*, 1970. Page 67: *Santa's Village Cave; In and Out*, 2005–8. Two chromogenic color prints, 40 1/4 x 72 inches (102.2 x 182.9 cm) each. Collection of the artist; courtesy Hauser & Wirth London/Zurich.

Printed and bound in the United States
10 9 8 7 6 5 4 3 2 1

Note to the reader: All works are by Paul McCarthy unless otherwise indicated.

CONTENTS

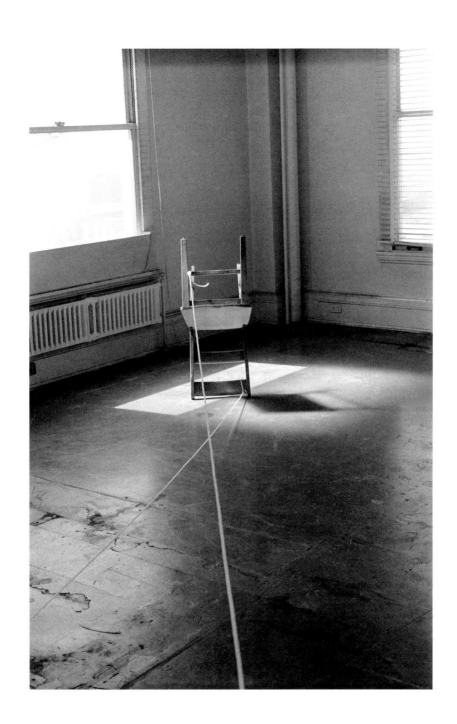

PREFACE

Paul McCarthy is widely acknowledged as one of the most important artists of his generation, and he is a major figure in the history of American art. It is an honor to be presenting this exhibition of his work at the Whitney Museum of American Art and a privilege to be given the opportunity to work closely with him. *Paul McCarthy: Central Symmetrical Rotation Movement—Three Installations, Two Films* brings together for the first time a group of works that deal with a core element of McCarthy's thinking: the way in which physical and psychological destabilization is made to occur through the body's interaction with dislocated architectural space. This question has been central for McCarthy since his earliest experiments with destruction in painting and performance in the 1960s, and it continues to be a major theme in his work today.

The exhibition presents three large installations: one from 1992 (*Bang Bang Room*) and two made especially for the exhibition (*Spinning Room* and *Mad House*). The moving walls of *Bang Bang Room* collapse our sense of stable architectural space, while the mirrored space of screens, projectors, and rotating cameras of *Spinning Room* realize a proposal McCarthy made in 1971. *Mad House*, another kind of spinning room, is constructed of a room with walls, an interior, and a chair that spin independently and together, creating a disturbing metaphor of physical and mental disorientation. The exhibition also presents, for the first time since they were created, two previously lost films: *Couple*, made in 1966, and *Spinning Camera, Walking, Mike Cram Walking*, made in 1971. Both films use the camera to track people as they move around their respective rooms, leaving haunting traces of the body's presence in physical space.

The exhibition also includes a group of related drawings and photographs, as well as a 1971 slide projection piece, *May 1, 1971*, created from thirty-six photographs taken by McCarthy while standing on a Los Angeles street corner. The result is a kind of stop-motion record of how the perception of a specific place can alter over a given period of time.

The disorientation that occurs in all the works in the exhibition is formal, corporeal, and psychological. At the core of their implications of anxiety and destabilization lies an almost ethical impulse to question everything—to turn it upside down, see it from an opposite angle, release the body from accumulated patterns, perceive with the brain as well as with the eyes, and bring the viewer to a state of not knowing what is the "right" side up. This inversion of logic is a way of opening up our thinking. McCarthy's work

is that of a painter turning a work inside out so completely that it becomes sculptural, architectural, performative, photographic, filmic, and conceptual. The cumulative nature of his process refuses singular containment, whether it is of material, medium, space, or art-historical context. A plunge into McCarthy's work can take the viewer from Francis Picabia, Yves Klein, and Francis Bacon across to Gustav Metzger and Yoko Ono through to the films of Alfred Hitchcock, Kurt Kren, and Michael Snow by way of Disneyland, Michael Jackson, the mines of Utah, and the Alps of Bavaria. The complex journey through this labyrinth of references creates a *gesamtkunstwerke* of experience, where, as in Aby Warburg's "Denkraum" (a space of thinking), getting lost enables us to find something.

McCarthy is striking not only for the extraordinary body of work that he has produced since the late 1960s but also for his extensive knowledge of art history, his commitment to (and support of) other artists, and his curatorial projects in art and film. The exhibition is accompanied by a film series, *Film List*, curated by McCarthy, which includes the work of Bruce Conner, Stan Brakhage, Gus van Sant, Yves Klein, and others, as well as screenings of *The Sound of Music*, projected upside down and backward.

Putting this exhibition together required an enormous amount of effort, particularly because new works were made, and I am deeply grateful to McCarthy for his trust, support, and commitment to the project. I am especially grateful to Karen McCarthy for her patience, support, and hospitality throughout the project and to Damon McCarthy. The McCarthy studio team worked tirelessly, and I would like to thank them all for their extraordinary work. The efficiency and professionalism of Amy Baumann, Kate Costello, Ann-Marie Rounkle, and Dinh Thai ensured that the project and all its many details proceeded smoothly from beginning to end. The daunting challenge created by the two complex new works was more than met by the technical team at the studio. Tom Whitson, David Kindlon, John Dawe, Blake Bolger, Dru Smith, and Pete Ross built *Spinning Room*, and their technical expertise and skill finally turned a major idea from more than thirty-five years ago into a reality. *Mad House*, with its equally complex technical demands, was built by Chas Smith, Tom Whitson, Andrew Matthews, and Brian Bertino. I salute them all; without their work, the exhibition would not have been possible.

Major support for the exhibition has been provided by the National Committee of the Whitney Museum of American Art in honor of Linda Pace, and generous support has been given by Allison and Warren Kanders. Their belief in Paul McCarthy's work is exemplary. We are grateful to Iwan Wirth and Marc Payot from Hauser & Wirth London/Zurich, for their generous sponsorship of the catalogue and for all their help with the exhibition.

At the Whitney, I would like to thank Adam D. Weinberg, Alice Pratt Brown Director, and Donna De Salvo, Chief Curator and Associate Director for Programs, for their faith in the exhibition and great support. My colleague Gary Carrion-Murayari, curatorial assistant, has worked tirelessly on the exhibition with me, and his insights and hard work have made an invaluable contribution to the project and the catalogue. Rachel de W. Wixom and Beth A. Huseman are to be thanked for bringing this book to fruition as impeccably as always and in record time. Garrick Gott's design has produced a book that, from the moment it is rotated to determine which way is up, provides an intuitive container for the scholarship it holds. I am also grateful to Jovana Stokic and Kate Brown for their research for this catalogue.

I would also like to thank Jeffrey Bergstrom, Richard Bloes, and Jay Abu-Hamda for their technical expertise installing the film loop and slide and video works; Graham Miles for heading the installation team; and Christy Putnam, Lauren DiLoreto, and Mark Steigelman in the Exhibitions and Collections Department for all their hard work coordinating and building the exhibition.

Finally, and most importantly, I would like to thank Paul McCarthy. The chemistry of an exhibition takes place on two levels: on a public level, where a synergy occurs between a group of works brought together around an idea, and on a less visible level, in the dialogue that takes place with the artist in bringing that group of works and ideas together. The discussions that occurred throughout the evolution of this exhibition have been of the highest order, and they resulted in an assembly of an exceptional group of works and fostered deep thought about time, physical space, and perception, which confirms McCarthy as one of the most important and influential artists of our time.

BAROQUE, MOI
VERTIGINOUS, I
PAUL MCCARTH
POLITICS OF SF

Chrissie Iles

ODERN,
EXISTENTIAL:
HY AND THE
PACE

Now suddenly the world spins out of control. The spinning world takes control, and, as the nausea mounts, all sense of a self in command of things from the center is sucked away. You are subject to the world as an unstoppable destructive force, thrown out away from you and collapsing in upon you, continuously. You are a world rushing toward a vanishing point where nothing can be distinguished from anything else.

—Christopher Green, *Picasso: Architecture and Vertigo*[1]

Medatating

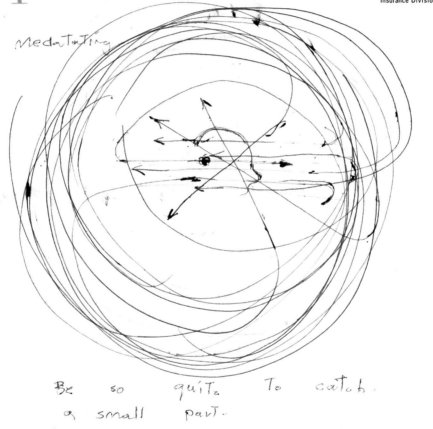

Be so quite. To catch.
a small part.

Waiting for a stream to
flow through.

Of all the artists who emerged out of the transformative period of the 1960s in America, Paul McCarthy arguably expresses the existential neurosis released by that moment in its most extreme form. As Marcus Raskin observed,[2] Stephen Spender described the 1950s, the period during which McCarthy grew up, as the "age of anxiety," characterized by a paradoxical combination of "angst and possibility...modern life in the West seemed to be an existential void... the people in the land of promise...made a nation of lonely people." Despite the triumphs of World War II, Raskin suggests, Americans felt "marginal and insecure." In the middle of the cold war, "violence came to be integrated in a new social system, the national security state," fearful of, and ever-ready for, a third world war.

McCarthy came of age as an artist in the mid-1960s, at a moment when culture had begun both to articulate, and rebel against, this collective social anxiety and codified violence. In Happenings (Fluxus and Neo-Dada actions), artists such as Gustav Metzger, Ralph Ortiz, John Latham, Wolf Vostell, Nam June Paik, Yoko Ono, and others demonstrated a preoccupation with destruction, demolishing cars, television sets, pianos, books, picture frames, musical instruments, and canvases—all material products and cultural symbols of a capitalist, bourgeois Western society whose value system was being overturned by a generation transformed by the Vietnam War, civil rights, Black Power, a widespread drug culture, and the women's movement.

McCarthy, at art school in Utah, became aware of these artists' work and the 1966 symposium "Destruction in Art" (initiated by Metzger) through art magazines and embarked on his own destructive experiments.[3] Arranging furniture on a stage to resemble a domestic room, he smashed it to pieces with a chainsaw and hammer while a rock band played behind him. In 1967, he also planned to use a bulldozer to destroy an abandoned house, which was surrounded by bleachers for the audience. The project was stopped by the city. The anxious mood of McCarthy's parents' generation was being brought to a head by the next generation

through a dramatic creative catharsis. Jeff Nuttall, a key figure in the London underground, wrote in 1968 that "[Hermann] Nitsch lamented the fact that corpses were available to medical students but not artists. So did we....Sickness was, for many, a will to enact some ceremony of violence that would spend the aggression inherent in the collective subconscious, exorcise it and leave society cleansed of fear."[4] In Utah, McCarthy demonstrated a similar interest, proposing that a dead horse be brought into the art school, laid on the stage, and theatrically lit.

Maurice Berger argues that "the aesthetic recreation of violence, psychosis and desire [during this period] was, at least superficially, related to contemporaneous methodological shifts in the treatment and understanding of psychosis."[5] Artists began to question the repressive effects of social conditioning on the individual, listening to psychiatrists like R. D. Laing (an important figure for McCarthy), who argued that madness could be precipitated by the repression of human impulses.

McCarthy understood this instinctively, using destruction as a recuperative tool to symbolically dismantle the structures of authoritarianism, through three of its most potent conduits: architecture, the body, and painting. McCarthy's earliest work includes a series of black Masonite paintings that he set on fire and attacked with a hammer. Looking at early British Pop paintings by Allen Jones, Richard Hamilton, and Peter Blake, he began to divide his paintings into rectangles, which he thought of as rooms. He linked these

1. Christopher Green, *Picasso: Architecture and Vertigo* (New Haven, Conn.: Yale University Press, 2005), p. 38.

2. Marcus Raskin, "Ed Kienholz and the Burden of Being American," in *Kienholz: A Retrospective* (New York: Whitney Museum of American Art, 1996), p. 39.

3. McCarthy attended the University of Utah in Salt Lake City.

4. Jeff Nuttall, *Bomb Culture* (London: MacGibbon and Kee, 1968), p. 145.

5. Maurice Berger, "Forms of Violence: Neo-Dada Performance," in *Neo-Dada: Redefining Art, 1958–62*, by Susan Hapgood (New York: American Federation of Arts, 1994), p. 80.

Opposite: *Meditating Financial Federation Drawing*, 1971. Ink on paper, 11 x 8 1/2 in. (27.9 x 21.6 cm). Collection of the artist; courtesy Hauser & Wirth London/Zurich

This page: Gustav Metzger, *South Bank Demonstration*, 1961

6. Briony Fer, *On Abstract Art* (New Haven, Conn.: Yale University Press, 1997), p. 79.

7. Ibid.

8. Thomas McEvilley, "Location and Space in the Kienholz World" in *Kienholz: A Retrospective*, p. 49.

9. Ibid.

10. Ibid.

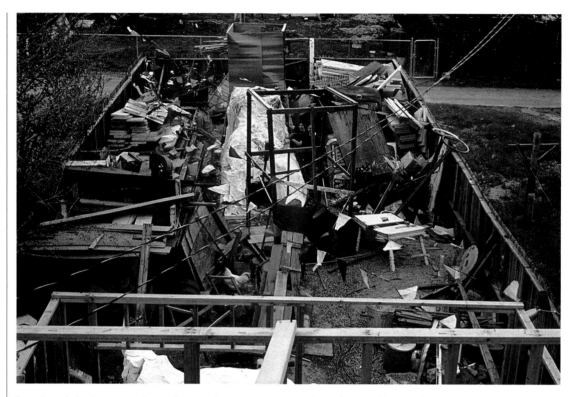

Wednesday Night Class, Work Yard of The Collective, 1969–70. Collection of the artist; courtesy Hauser & Wirth London/Zurich

four-by-eight-foot wood panels together to create large wall paintings. His final black painting, made on three panels, showed a gridded octagonal shape floating in space, as though an architectural form existing in a black void. McCarthy later burnt it.

As Briony Fer, discussing George Bataille's work on the subject, argues, the impulse to destroy painting is one of modern painting's fundamental concerns.[6] In this sense, McCarthy's actions, and all his subsequent engagements with painting, fall within a long history of modern painterly practice. Bataille goes further, declaring that "doing violence to representation forms the basis...of any representational act...[all] art proceeds by successive destructions."[7] McCarthy's destruction and dismantling is spread across multiple disciplines from painting, sculpture, and drawing, to performance, video, film, installation, and architecture, through which the body expresses the condition of the alienated self. In McCarthy's work, the body is manifested both corporeally and as architecture, housing, but also trapping, the unconscious. As both the container

and producer of internal anxiety, architecture becomes an oedipal figure that McCarthy dismantles, acts out within, and rebuilds, creating structures that not only occupy the same space as the body—they *become* the body.

McCarthy's emphasis on the viscerality of the body in physical space reflects an engagement with volume that, as Thomas McEvilley argues,[8] characterized the approach of many artists working in Los Angeles during the 1960s, in particular light and space artists such as James Turrell, Larry Bell, and Robert Irwin. But unlike their focus on immateriality, in McCarthy's architectural installations, as in those of Kienholz before him, space functions as "an oppressive force,"[9] exploring not openness, but a sense of being physically and psychologically trapped inside a void. McEvilley describes the identification of two kinds of absence in the Vaisesika school of Indian philosophy: prior absence, in which an empty volume anticipates the imminent appearance of something; and posterior absence, which denotes the absence of something after it has already happened.[10] McCarthy's work, by contrast,

articulates a state suspended somewhere between the two, in which something is in the process of happening, or has just happened, but is never finally released or resolved.

This ambiguous spatial state is brought about by the introduction of movement, projection, and repetition. The spectacle of the opening and closing of walls, doors, and ceilings, and spinning—of the body, or of an entire room—is intrinsically theatrical. But the endless repetition of motion creates a circular structure that refuses linear narrative and suggests infinity. Where traces of past activity—painted marks, debris, overturned objects and furniture—are contained within a static enclosed space, "posterior" absence is negated by the presence of a perpetually repeating video loop of recorded action.

The structure of looped action paradoxically reconstructs the condition of the static painterly image, as movement becomes, through repetition, capable of receiving prolonged contemplation. The combination of anxiety and contemplation in McCarthy's structures evokes the paintings of Francis Bacon, whose influence he has acknowledged. As Martin Harrison observes: "Bacon's spaces were oedipal spaces...sites for the re-enactment of infantile traumas, rooms in which he projected his 'nervous system' onto canvas...His principal theme devolved on the inner realities of people confined in rooms...The studio was a type of camera, but...instead of a lens, [a] circular mirror...cast back from its central position on the end wall a dim, interrupted reflection of the interior...in his theatre-of-action, figures arose from his imagination, occupying perverse spaces and assuming distorted attitudes."[11] McCarthy's desire simultaneously to occupy, invert, and dismantle rooms, holes, tunnels, and voids suggests a similar impulse to create an "oedipal" space structured as a form of camera. As Freud suggested, "we should picture the instrument which carries out our mental functions as resembling a compound microscope or a photographic apparatus." Both Bacon and McCarthy demonstrate Walter Benjamin's identification of technology as a site of struggle,

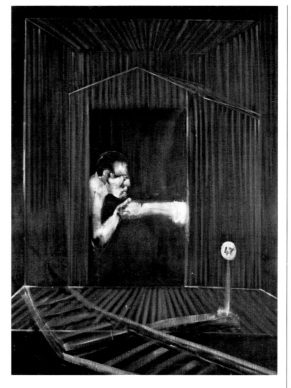

within which, to quote Rosalind Krauss, "the experience of an archaic, infantilized desire irrupts inexorably...creating, ever so fleetingly, a space of resistance to [technological] rationalization."[12] Krauss's words, analyzing Duchamp's eroticized model of visuality, evoke McCarthy's description of his own architectural structures as models of the unconscious. Within Krauss's model of the "optical unconscious," as in McCarthy's rooms, the self becomes decentered and its identity repeatedly fractured. This is clearly articulated in *Bang Bang Room*, a twelve-foot-square room constructed out of plywood, whose four walls repeatedly open outward from each corner then, when fully extended, move back inwards, reconstituting themselves back into an enclosed cube. Within each wall an unsecured door flaps open and shut, banging loudly as the walls move in and out. The walls' interior surface is covered in old wallpaper, while their exterior plywood construction remains exposed, like a film set.

The exposed structure of *Bang Bang Room* evokes McCarthy's childhood home in Utah, which he

11. Martin Harrison, *In Camera, Francis Bacon: Film Photography, Film, and the Practice of Painting* (New York: Thames and Hudson, 2005), p. 113.

12. Rosalind Krauss, *The Optical Unconscious* (Cambridge, Mass.: MIT Press, 1993), p. 142.

Francis Bacon, *The End of the Line*, 1953. Oil on canvas, 60 x 46 in. (152.4 x 116.8 cm). Collection of Samuel and Ronnie Heyman

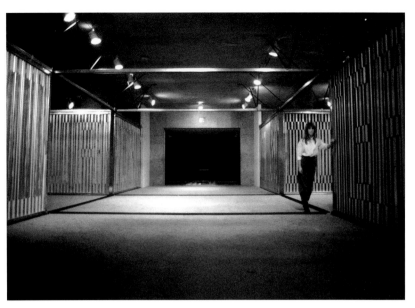

from the contemplative space of painting that, as Robert Morris argues, is only breached if "the space of the viewer's body is invaded...he is provoked to movement or...his image becomes part of the work."[14] However, unlike Acconci, who emerged out of poetry, McCarthy, like Marcel Duchamp, Francis Picabia, and Allan Kaprow before him, breaks the space of painting but never completely rejects its influence. McCarthy's opening out of pictorial space into real space in *Bang Bang Room* resembles the movement of multiple picture planes, at the center of which exists a void that is intermittently occupied by a human presence. McCarthy beckons in the image only to empty it out, evoking Christopher Green's discussion of Picasso's paintings through a model of architecture and vertigo, citing *Painter and Model* (1928), in which the figure/ground composition forms a tension between the "static accents" of the object in the center of the painting, and the "flight of visions," or "vertigo," implied by the dynamic movement of the surrounding tectonic planes.[15]

McCarthy's paradoxical approach develops ideas explored in Kaprow's *18 Happenings in 6 Parts* (1959), a structure of three interconnected rooms with interior walls made of semi-transparent plastic, some of which are painted, or covered with objects or projections, and several open doorways. The assembled viewers operate as a passive audience, moving between rooms in groups, watching people perform scored actions within one room before being instructed to move on to the next. Each set of actions and viewers was visible to the others through the open doorways and semitransparent walls. Kaprow's semistatic structure, operating somewhere between painting, architecture, performance space, and sculpture, prefigures McCarthy's *Bang Bang Room*. However, McCarthy's perpetually moving interior removes Kaprow's delineation of viewers as audience, creating a stage on which anyone can perform.

This stage is revealed as *Bang Bang Room*'s four walls open outward like angled theater curtains, exposing a slightly raised square wood floor. The viewer can either walk around this empty stage

13. Vito Acconci, *The City Inside Us*, ed. Karin Wolf (Vienna: MAK), p. 84.

14. Robert Morris, "Solecisms of Sight: Spectacular Speculations," *October* 103 (Winter 2003), p. 33.

15. Green, *Picasso*, p. 28.

describes as a house situated in a small collection of streets built hurriedly for veterans at the end of the Second World War. While the front door of the house led to the street, the back door opened out into an empty landscape stretching into the distance. McCarthy's structure echoes this ersatz environment, whose paradoxical combination of suburban domesticity and emptiness provided an early model for McCarthy's work.

The engagement with symbolic architectural space in *Bang Bang Room* echoes the important role played by architecture in the work of a number of artists who emerged in the late 1960s, from Bruce Nauman, Dan Graham, and Gordon Matta-Clark to Mary Miss and Vito Acconci. For all these artists, architecture became a performative field within which to explore issues of social interaction. Acconci's architectural installation *Room Dividers* (1982), for example, allows viewers to manually move walls back and forth, changing the original boxlike space into multiple enclosures. Acconci's structure creates another kind of anxious space, constructed by the viewers themselves: "As the walls make physical divisions within the space, they function as markers for psychological and social divisions: they divide the people in the space into sides."[13] Acconci's grounding of the viewer's experience in social interaction marks his approach as a distinct break

Vito Acconci, *Room Dividers*, 1982. Corrugated aluminum, spray enamel, door-track: eight units, 8 ft. x 16 ft. x 24 in. (2.4 m x 4.8 m x 60 cm) each. Collection of the artist

or occupy the centre of it by quickly stepping onto it between the moving walls, first visible then disappearing from sight as the walls close in. They can move on or off the stage at any time during the cycle, alternating between spectator and participant. The acute diagonal angles refuse the frontality of the proscenium arch, echoing the structure of theater-in-the-round. Yet the slow movement of the heavy walls in and out also anthropomorphizes the room, turning it into a large lumbering machine. Instead of operating as a frame or passive container, the room takes on a life of its own, appearing to multiply as its vistas open up, scattering viewers across the room.

The film set quality of *Bang Bang Room* and its oscillation between room and machine suggests Walter Benjamin's interpretation of "technik," which he understood not simply as technology, but more broadly as "production." The film set is a tool of production, in which reality is re-constituted into a dream-like form for mass consumption. But *Bang Bang Room* presents us with a broken production, in which nothing ever achieves a final resolution. If "technik," or production, historically produces alienation, the disturbing quality of McCarthy's collapsing domestic room could be read not only as a site of existential angst, but as a symbol of a larger struggle. The breaking of the American fantasy of suburban domestic contentment and stability belies a wider challenge to the oppressive hand of technologized corporate social control.

The repeated movement in *Bang Bang Room* evokes Sigmund Freud's classic psychoanalytic model of "fort/da," in which a small boy rationalizes the anxiety felt at the disappearance of his mother by throwing a reel on a string out of his crib ("fort" [away]) and pulling it back in again ("da!" [there]). The mastery of his anxiety through the experience of this repeated symbolic absence is evoked in McCarthy's room, as it collapses and reconstitutes itself over and over again. Its two opposite states, "heimlich" (homey) and "unheimlich" (uncanny, or disturbing) echo Vidler's observation that the uncanny principle "[is] simultaneously established and de-stabilized... joining these two opposites [is] the notion of

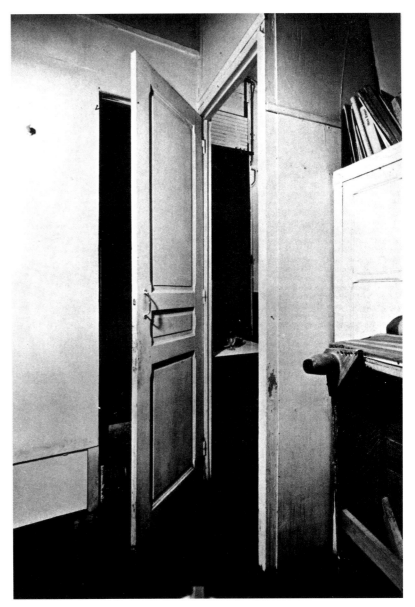

something once buried and then reappearing."

Yet in *Bang Bang Room* the binary rhythm of Freud's model is fractured by the structure's swinging doors and moving walls, which make a loud banging noise that is at once aggressive and suggestive of an abandoned space. The multiple openings leading nowhere recall Marcel Duchamp's *Door, 11 rue Larrey* (1927), which shows Duchamp's modification of the walls of his home so that one door served two doorways

Marcel Duchamp, *Door, 11 rue Larrey,* 1927. Wood door, 86 5/8 x 24 11/16 in. (220 x 62.7 cm). Collection of Fabio Sargentini

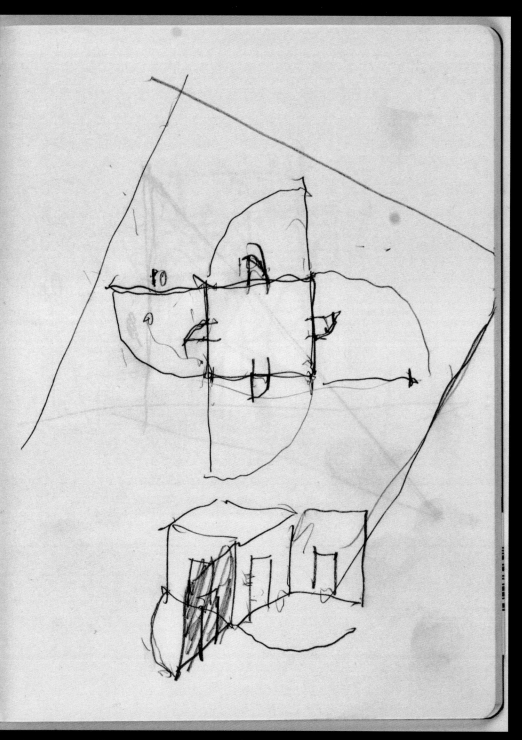

Bang Bang Room Drawing, 1992. Graphite on paper,
10 x 7 1/2 in. (25.4 x 19.1 cm). Collection of the artist;
courtesy Hauser & Wirth London/Zurich

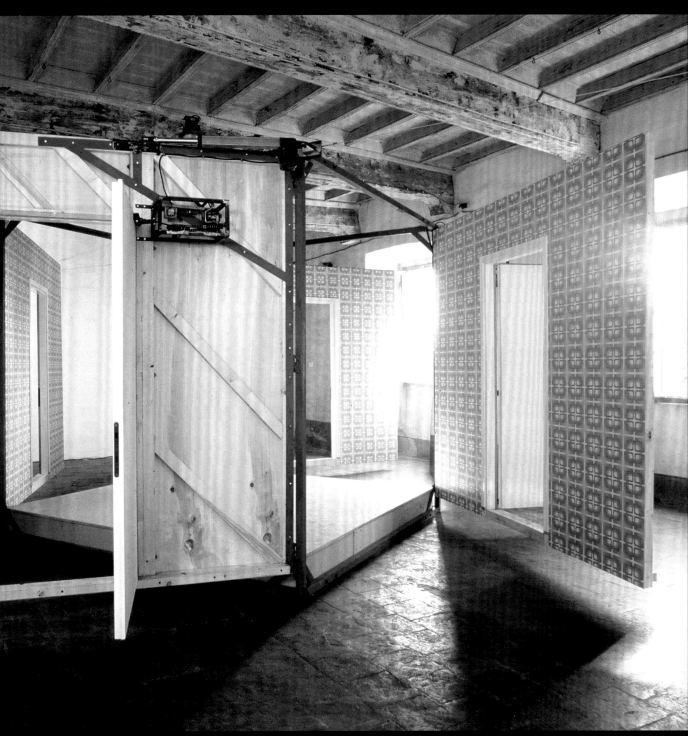

Bang Bang Room, 1992 (installation view, *Viaggio a Los Angeles*, Castello di Rivara, Turin). Wood, steel, motors,
linoleum, and wallpaper, 8 ft. 2 in. x 9 ft. 6 in. x 9 ft. 6 in. (2.5 x 2.9 x 2.9 cm) closed; 8 ft. 2 in. x 28 ft. 6 in. x 28 ft. 6 in.
(2.5 x 8.7 x 8.7 m) open. Collection Fondazione Sandretto Re Rebaudengo, Turin

16. George Baker, "The Split: Picabia and Modernity," (master's thesis, Columbia University, n.d.), p. 3.

17. Anthony Vidler, *Warped Space: Art, Architecture, and Anxiety in Modern Culture* (Cambridge, Mass.: MIT Press, 2000), p. 92.

18. John Rupert Martin, *Baroque* (New York: Westview Press, 1977), p. 161.

19. See McCarthy's *Bavarian Kick* on p. 60.

20. Karsten Harries, *The Bavarian Rococo Church: Between Faith and Aestheticism* (New Haven, Conn.: Yale University Press, 1983).

21. Robert Morris, *Continuous Project Altered Daily: The Writing of Robert Morris* (Cambridge, Mass.: MIT Press, 1995), p. 166.

22. Ibid.

bisecting three rooms—his studio, his bedroom, and the bathroom. Duchamp manages to render the door both open and closed simultaneously and, like McCarthy, defies the logic of binary oppositions, in this case by introducing a third room. In both cases, architecture becomes a metaphor not only for the individual as a fragmented subject, but for the shattering of the binary, stereoscopic structure of vision itself.

Duchamp's collapse of a stable spatial logic is echoed in McCarthy's *Skull Card* (1967), a cardboard rectangle with two holes hanging from a string at eye level. When the viewer stands up to look through the holes, the space they occupy suddenly becomes interior, and the space beyond the *Skull Card*, now functioning as a mask, becomes the exterior. *Skull Card* materializes the function of the persona in a way that becomes psychological, perceptual, and architectural. This fragmentation of vision and space is symptomatic of the condition of the modern. George Baker describes the condition as it emerged at the beginning of the last century as "a modernity that produces not better, stronger, and faster, but the effect of too much, too fast, too often"— a modernity characterized by excess.[16] Such decadence, as Benjamin argued, links modernity back to the baroque, which, as Vidler describes, was "an art of extremes, one that presses the very limits of art to excess, even disappearance."[17] McCarthy's impulse toward disorientation, excess, and the collapse of the boundaries between the self and the artifice of depicted space arguably defines his work as belonging within this modern and baroque sensibility.

Baroque space, as art historian John Rupert Martin has observed, attempts to create a spatial continuum between artwork and real life. Projective by nature, it "[dissolves] the surface plane by means of emphatic recessional movements."[18] The layers opened up by the movements of the walls and doors in *Bang Bang Room* evoke this sense of recessive space. Baroque architecture, which rose to its most exaggerated form in Bavaria, with whose social culture McCarthy has long been engaged,[19] is characterized by an excess which echoes McCarthy's extended

sculptural forms. In Bavarian late Baroque architecture, as architectural supports receded, ornament, as art historian Karsten Harries explains,[20] came to the fore until it almost appeared to be attacking its support, rebelling against its own ornamental status and taking on the appearance of an independent sculptural form. The same could be said of *Bang Bang Room*, whose walls overwhelm its cubic shape with their projective movement like ivy taking over a tree. The resulting implications of infinity evoke the disconcerting architecture of the Winchester House, a Victorian mansion in San Jose, California, containing 160 rooms, each built onto one another in an ever-extending mass, by the eccentric heiress of the inventor of the Winchester rifle to house the souls of all the people whom the rifle had killed. Defying architectural logic, the rooms create an "uncanny" labyrinth of empty domestic space. Sarah Winchester's creation confirms the nineteenth-century perception of feminine space as uncontrollable, hysterical, and against the masculinely defined social order. It is exactly this kind of space that McCarthy repeatedly creates.

The trajectory of McCarthy's antirational spatial thinking can be seen in works such as *The Fornication Maze—Sex Maze* (1992), a structure made from brown office dividers. Large pieces of paper tacked on the walls have "left," "right," and "fornication" written on them. Drawings such as *Dead H (Crooked Leg)* (1979) describe similar recessive labyrinthine structures. In the 1960s Robert Morris suggested that "the labyrinth form is perhaps a metonym of the search for the self, for it demands a continuous wandering, a relinquishing of the knowledge of where one is. A labyrinth is comprehensible only when seen from above, in plain view, when it has been reduced to flatness and we are outside its spatial coil....[The] perception of things in depth returns us to our consciousness of our own subjectivity, which, like space itself, has no clear demarcation, no visible bounding limit."[21] Morris goes on to point out that "fixity is a function of notational systems, and notational systems exist in the flat world of surfaces...they are extra-spatial....If the physical world divides...between

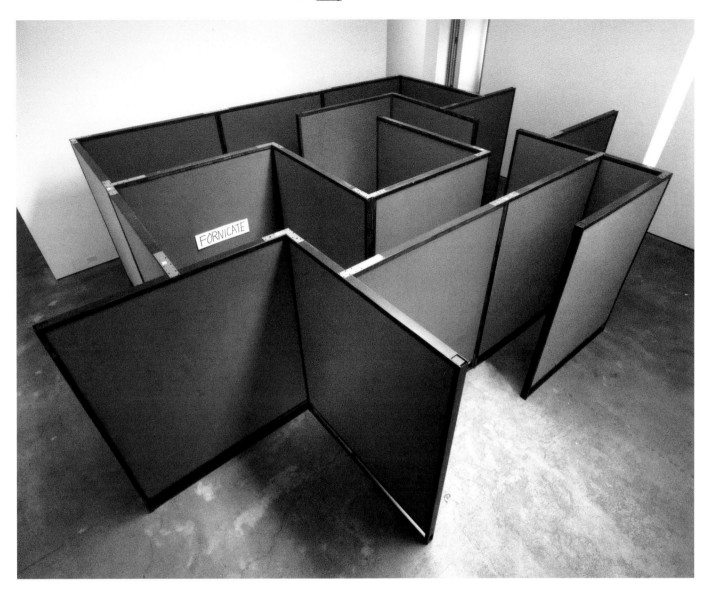

surfaces and depth, it is not a natural but a cultural division."[22] This cultural division, by which the surface of painting is conventionally separated from the depth of sculpture, has been challenged by artists since the Renaissance through the use of the mirror. The instant three-dimensionality introduced by reflection opened up the dimensional possibilities of painting in ways that both prefigure the camera and bring together its dual meaning, as prosthetic extension of the eye, and as room. The use of the mirror by artists in the 1960s and early 1970s, from Morris, Graham and Robert Smithson, to Robert Whitman (in particular his multiple mirror installation *Pond* [1968–69]), Joan Jonas, Acconci, Nauman, and others, usually in relation to the body, rejected the dominant language of American modernist abstract painting by reintroducing recessive space and the figure into art, through a camera-oriented structure of conceptual criticality. McCarthy demonstrates this in works such as *The Veil* (1970), a photograph in which he covered his head and shoulders in a veil and photographed himself through the veil, in front of a mirror. The layers of space demonstrate a complex relationship between the mirror, the camera, the body,

Fornication Maze—Sex Maze, 1992 (installation view, Rosamund Felsen Gallery, Santa Monica). Steel and linen office partitions, marker on poster board, 5 ft. 11 in. x 14 ft. 10 in. x 10 ft. 5 in. (1.8 m x 4.5 m x 3.2 m). Collection of the artist; courtesy Hauser & Wirth London/Zurich

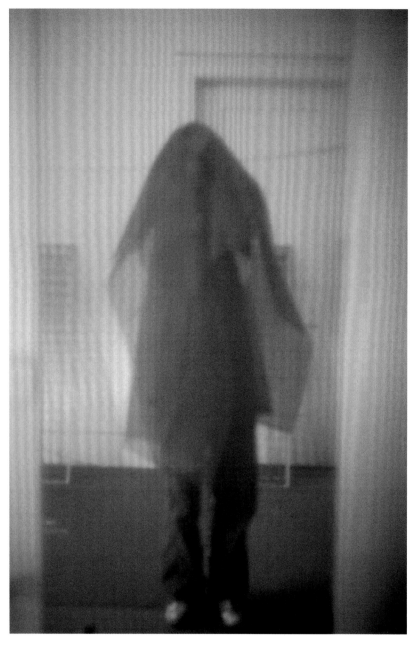

The Veil, 1970. Photograph of a mirror through a veil. Collection of the artist; courtesy Hauser & Wirth London/Zurich

conceals another, unseen room behind it, in a layering of space that evokes *Bang Bang Room*. This layering is echoed in material terms by the filtering of the image through the veil and the reflective surface of the mirror. The artist's concealment of both his eyes and the camera lens obscures the classical composition of a self-portrait. McCarthy's use of the mirror and camera recalls Harrison's observation that Bacon substituted circular mirrors for windows in his second studio. Harrison compares Bacon's perceptual experiments to Dziga Vertov's film *Man With a Movie Camera* (1929), in which "a close-up of the camera's lens fills the whole frame…it does not reflect back to the viewer an external scene, but the eye of a cameraman—of Vertov himself."[23]

The Veil presents a similarly tautological image, whose moving image equivalent in 1970 was the new phenomenon of video feedback. McCarthy got ahold of video equipment that year for the first time and used it to explore similar ideas performing in front of the camera. In *Spinning* (1970), he held his arms out and spun round the room near a corner, so that his hands brushed the walls on each rotation. His movement echoed the physical spooling of the videotape from one reel to another as it recorded his action. McCarthy's performance, made specifically for the video camera, evokes Bruce Nauman's *Revolving Upside Down* (1968/69), in which Nauman inverted a video camera set on the floor of his studio and recorded himself revolving bent over with his hands behind his back and making a number of other dance-related movements including arabesques and pirouettes.

McCarthy's and Nauman's bodily rotations achieve diametrically opposite results. Nauman's inverted camera, moving between distant and close-up, echoes the viewpoint of Nauman, whose body is bent almost double as he leans over to execute his slow and deliberate movements, looking down at the floor. By contrast, in *Spinning* the fixed camera dispassionately records McCarthy's movements as he spins fast, arms extended, creating a vortex that simultaneously takes over and empties out the

the surface of the veil, the flat image, and three-dimensional space. McCarthy adopts the stance of an old-fashioned photographer, standing with a dark cloth over his head, but the apparatus is invisible, de-masculinizing the gaze and creating a subtle void in the center of the image. The camera, hidden, like the upper body and head, under the veil, captures the room, the mirror, the image within the mirror, and a closed door that

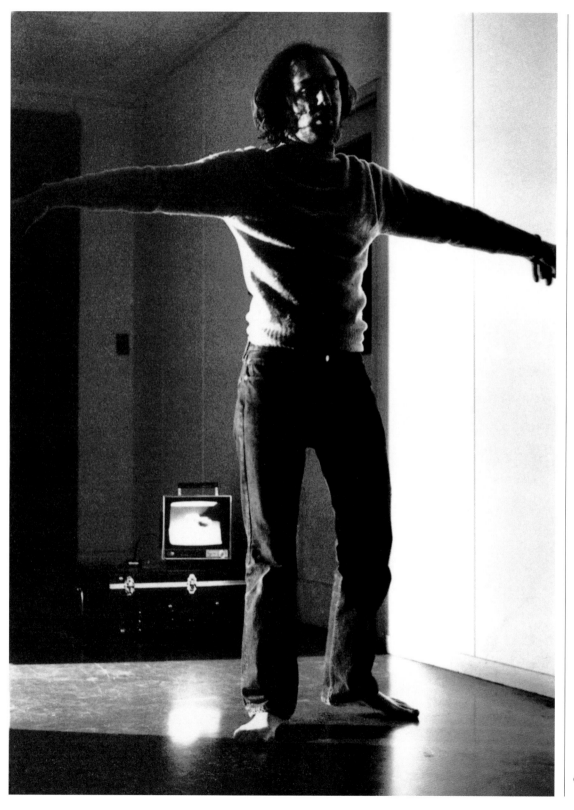

Spinning, 1970.
Photograph of performance.
Collection of the artist; courtesy
Hauser & Wirth London/Zurich

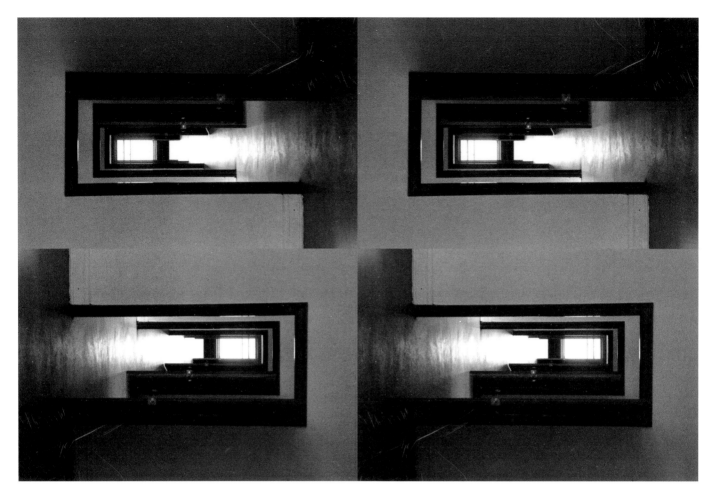

Inverted Rooms and Hallways,
1970. Four gelatin silver prints,
14 x 21 1/2 in. (35.6 x 54.6
cm) each. Whitney Museum
of American Art, New York;
purchase with funds from the
Contemporary Painting and
Sculpture Committee and Norah
Sharpe Stone 2001.138.1a

space. While Nauman occupies space McCarthy reconfigures it, shifting it from a formal to a psychological, feminized reading in which the body is spun into a kind of cast of itself. Just as with *The Veil*, *Spinnning* creates a void of anxiety bordering on hysteria in the centre of the image, refusing the static presence of an object, or body, standing in for the erect, vertical male.

As with spinning, the disappearance of fixity can also be enacted through mirroring and inversion, properties of both ocular vision and the camera lens. In the same year as the *Spinning* videotape, McCarthy made a series of photographs of the *H*-shaped architectural interior of a former induction center for the Vietnam War and World War II (now studios for art students at the University of Southern California). McCarthy had a studio in the center of the *H* of the seven-story

building. In his double photographs one image is right side up and the other inverted, juxtaposing the two moments of ocular perception. The resulting symmetrical double image creates a perceptual conundrum that implies another kind of spinning, in which the camera is rotated. This rotation implies either the rotation of the body, or the detachment of the camera from the upright body. Since vision is vertically defined, McCarthy's inversion suggests a retinal detachment from verticality (and therefore, gravity) similar to *Bang Bang Room*'s detachment from rectilinear stability.

McCarthy has spoken of "a fear of reflections," being perturbed by the potential loss of the ability to discern a mirror reflection—the site of what is known as "the imaginary" (our image of our body)—from reality. He further explains, "Only your memory tells you...what if you lost that?"[24]

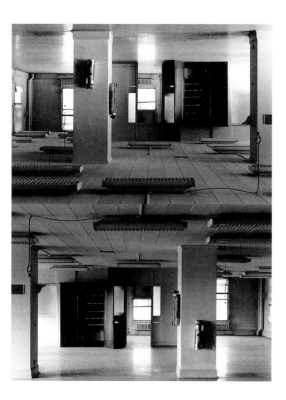

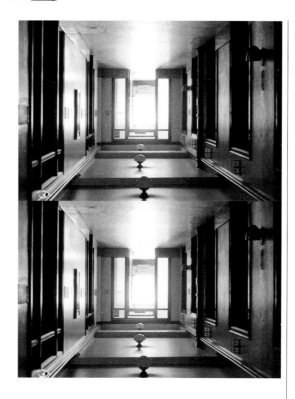

24. Paul McCarthy,
in discussion with the
author, March 4, 2008.

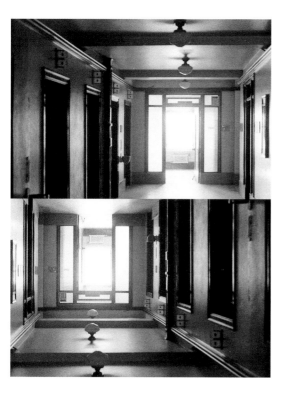

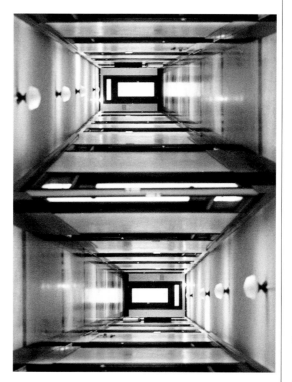

Inverted Rooms and Hallways,
1970. Four diptychs: gelatin
silver prints, 28 x 22 in. (71.2 x
55.8 cm) each. Whitney Museum
of American Art, New York;
purchase with funds from the
Contemporary Painting and
Sculpture Committee and Norah
Sharpe Stone 2001.138.1b-e

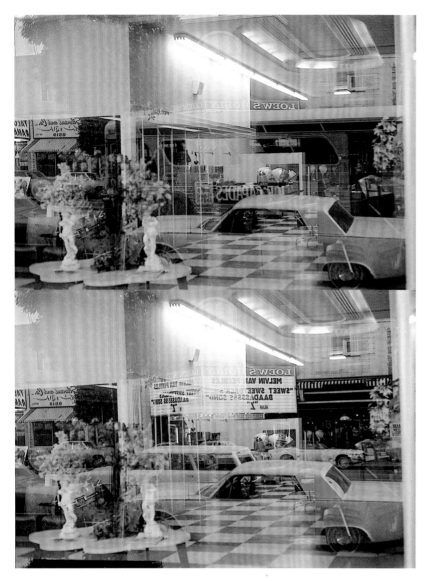

*Fear of Reflections
(Hollywood Boulevard)*, 1971.
Two chromogenic color prints.
Courtesy the artist and
Hauser & Wirth London/Zurich

entire frame. This pulling of the ceiling down toward the floor suggests another baroque inflection in its collapsing of space. Its sense of disorientation similarly underlines its origins in Baker's vertiginous modernity, illustrated in the note scribbled by Duchamp in his *Green Box* of 1919: "To place mirrored pieces of glass on the floor so that the room and the viewer are mirrored simultaneously."[25] McCarthy shifted the space of his mirror photographs in the large-scale *Sunrise Sunset*, of the same year, where he photographed a mirror placed on the east side of a valley in the Hollywood hills, facing the west. He photographed the reflection of the sun in the mirror, creating a paradoxical image in which the dark hillside was contrasted with the light of the mirror, which became brighter until, in the final photograph, it showed only a bright light.

The structure of these early mirror works pre-figures *Spinning Room* (1971/2008), a complex installation in which four large mirror walls enclose four double-sided screens. Inside the area enclosed by the screens a circular turntable housing four video cameras slowly revolves and rotates, throwing images of what it records live onto the mirrored walls and screens which, being double-sided, can be read from both sides, creating another form of mirror.

Spinning Room is a complex spatial synthesis of all McCarthy's early experiments with projection, reflection, spinning, inversion, symmetry, and rotation.[26] Unlike *Bang Bang Room*, in *Spinning Room* the viewer is implicated in the work the moment they step into the field of the piece, unimpeded by moving walls. In *Spinning Room* the movement occurs within the image, which interacts with a double-layered open cube shape whose physical orientation remains stable. The disorientation occurs through the mirror, the camera and the screen, which substitute the passively spinning viewer for the actively spinning artist. Instead of a single void, McCarthy fragments space to such an extreme degree that the viewer shatters into multiple fragments, glimpsed as they slide along the mirror, off the screen, and into the four voids between the mirrors, and between the screens, into the gallery space beyond.

McCarthy's fear could be read, in Lacanian terms, as anxiety regarding the possible breakdown of the relationship of the self (the imaginary wholeness) to the world (the fragmentary real).

McCarthy makes this anxiety clear in *Mirror Photographs—Spiral Cone Shape* (1971), a grid of black-and-white photographs of a piece of mirror on the floor, photographed in a sequence by moving increasingly closer in a spiral movement until the camera is almost touching the mirror, which, in the final photograph, reflects an image of the ceiling above, occupying the

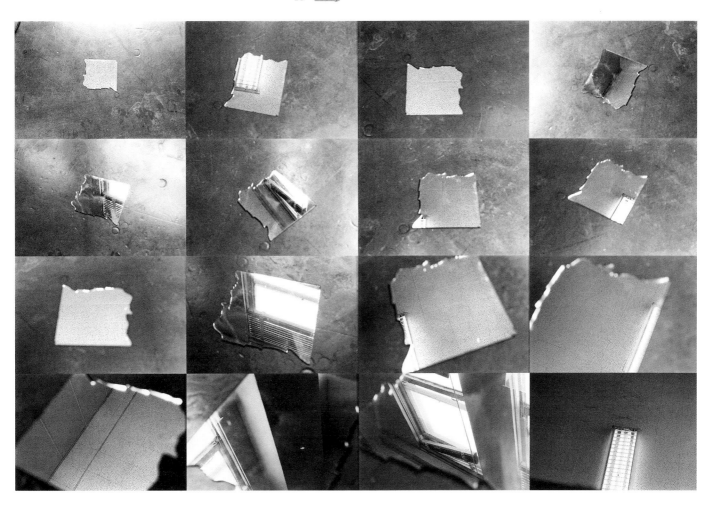

In this dizzying environment, inversion occurs not only vertically, but also in planar terms. The imagery on the front of the screen is a reflection of what has been reflected onto the back of it, from the mirror. Which side, then, is the front? McCarthy renders this question unanswerable. His dismantling of the hierarchy of front versus back, another blow to painting, recalls Lewis Carroll's interest in mirror reflections and backward handwriting. Carroll's second children's book, *Alice Through the Looking Glass*, was inspired by meeting in London a little girl, Alice Raikes, whom Carroll invited to hold an orange in her right hand, while looking into a mirror. When asked in which hand the orange was held, the child answered, "the left" and asked whether the orange would still be in her right hand if she were on the other side of the looking glass.

In *Spinning Room*, the viewer is always on the other side of the looking glass, unable to determine whether we are inside the space or outside it. This disconcerting experience is prefigured in *Bang Bang Room*, where the internal and exterior walls are folded inside each other, appearing side by side. In *Spinning Room*, reflection and inversion dismantle this even further, creating a distance between our physically embodied, three-dimensional selves and their disembodied fragmentary representations, seen drifting across disjunctive planes of reflected and projected space.

This reading of images generated by a camera detached from the eye was famously explored in filmic terms in Michael Snow's film *La Region Centrale* (1969), which was of interest to

25. Chrissie Iles, *Into the Light: The Projected Image in American Art, 1964–1967* (New York: Whitney Museum of American Art, 2001), n. 16.

26. *Spinning Room* relates to an unrealized proposal made by · McCarthy in 1970 for a video installation involving four monitors and cameras placed in a circle.

Mirror Photographs-Spiral Cone Shape, 1971. Photographic series. Collection of the artist; courtesy Hauser & Wirth London/Zurich

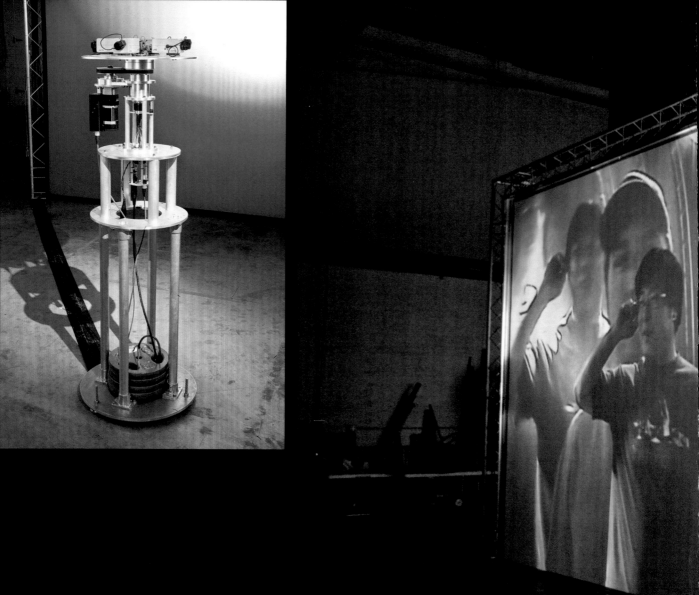

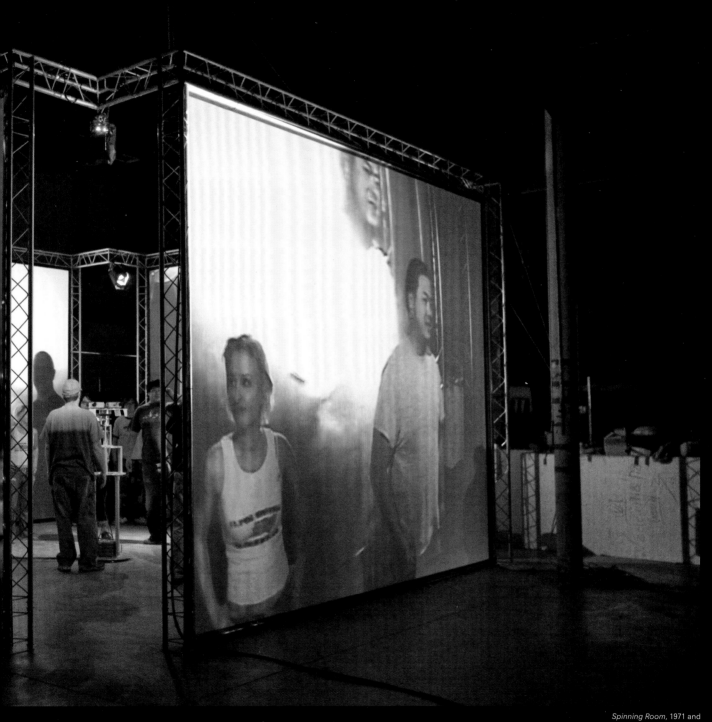

Spinning Room, 1971 and
2008. Production photograph.
Collection of the artist; courtesy
Hauser & Wirth London/Zurich

spin room

4 spining cameras
4 projectors

Mirror
Box
2001

feedback showing the 4 cameras
and the 4 projectors cameras

4 3 2 1

3

2

feedback
no feedback.
reverse direction
upside down.

Spin Room

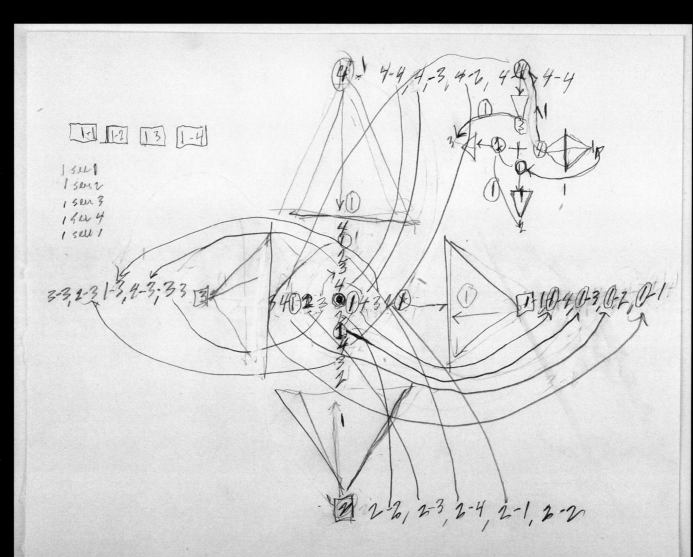

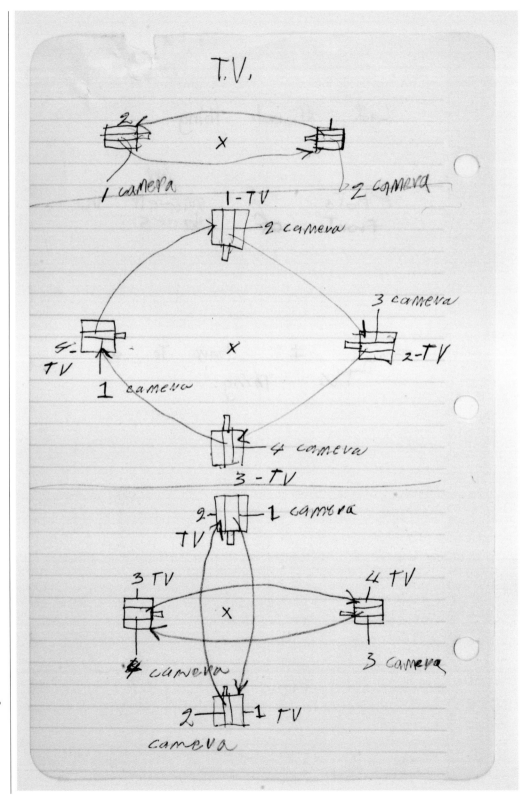

Cameras and Televisions
Drawing, 1971. Ink on paper,
8 1/2 x 6 in. (21.6 x 15.2 cm).
Study for three video works (top
to bottom): two cameras, two
TVs, stand on X; four cameras,
four TVs, stand on X, rotation,
profile; four cameras, four
TVs, stand on X, cross, back
of the head. Collection of the
artist; courtesy Hauser & Wirth
London/Zurich

McCarthy. Snow attached a film camera to a large motorized apparatus that could move in a 360-degree arc up, down, or in a spiral or circle, filming the surrounding space (a mountaintop in North Quebec, Canada) from every angle. Snow's apparatus resembles *Spinning Room*'s quadruple camera turntable set-up, erasing the conventions of cinematic space as radically as McCarthy detaches us from the coordinates of the white cube of the gallery. The layered reflectiveness in *Spinning Room* once again evokes the excess of Bavarian late baroque and rococo architecture; the viewers do not so much occupy a room as take it over, becoming the architecture. It is hard to determine which McCarthy wants to disappear more—the body or the architecture housing it.

The negation of the relationship between image and wall through erasure and projective rotation invites comparison with Robert Morris's *Finch College Project* (1969), an installation in which a 16-mm camera rotating on a circular pedestal in the center of the room recorded a team of people installing and de-installing a gridded photograph of a cinema audience, and, on the opposite wall, a gridded mirror of the same size that reflected the image and the action of removing it. The resulting film of the action was then projected around the walls of the room on the same rotating turntable, screening the past presence of the photograph and mirror onto the now empty walls and the markings on them left by the adhesive, the film and the actual markings occasionally overlapping as the image revolved.

The rotating turntable of *Spinning Room* also projects images around the walls, but multiplies them into four separate live projections of viewers and the gallery space, creating a mirroring through instant feedback that recalls Dan Graham's mirrored video environments and Peter Campus's live-feed installations. It also builds on two little-known and, until recently, lost films that McCarthy made in 1966 and 1971.

Michael Snow, Still from *La Region Centrale*, 1971. 16mm film, color, sound; 180 minutes.

27. These missing films include some animation films, made when McCarthy was a post-graduate student at the University of Southern California, where he studied in both the art and film departments. The film department focused strictly on traditional narrative film (producing directors such as George Lucas), and the most sympathetic teacher there was the animation professor. McCarthy made a series of animation films including *Film of Desire*. See Iwona Blazwick, *Paul McCarthy: Head Shop/Shop Head* (Stockholm: Moderna Museet, 2006) for images. In this film, McCarthy, preoccupied with subliminal advertising at the time, shot pages of magazines with an animation camera.

28. Krauss, *Optical Unconscious*, p. 142.

29. Baker, "Split," p. 4.

30. George Baker, *The Artwork Caught by the Tail: Francis Picabia and Dada in Paris* (Cambridge, Mass.: MIT Press, 2007), p. 291.

In the ten-minute black-and-white film *Couple* (1966), McCarthy pans a camera around a semi-darkened domestic room containing a naked couple, who walk around, sit watching television, and lie on the bed. The camera's focal point has been set to two to three feet, throwing everything beyond that point into a semi-abstracted soft focus. Everything comes into sharp focus when in extreme close-up; the woman's profile, next to an image on the television set and a detail of a bathroom shelf, where a hairbrush, hairpins, a Q-Tip, and hairspray are clearly visible. At one point the woman holds her breast toward the camera in a seemingly random maternal gesture. The camera adopts a position similar to that of a baby, whose entire focus is on the mother's body and occasional glimpses into the world beyond.

McCarthy rejects the conventions of traditional filmmaking, folding the intimacy of the room and the naked bodies moving around it into a language of structural film, where we become aware of the mechanics of the apparatus. McCarthy uses this structural technique to make us aware that the camera's fixed focus is refusing to create the distance from the image that allows us to fully recognize the other as "other." McCarthy added to his "fear of reflections" a "fear of mannekins"—what if you could not tell the difference between a mannekin and a real body? In *Couple*, the viewer is never able to understand the body as fully cinematic, and therefore imaginary, since the flowing intimacy of its surface in extreme close-up keeps us connected to (and almost suffocated by) it, as though it were real.

As in McCarthy's installations, his films shift between claustrophobia and elusiveness. If *Couple* evokes the close-up disorientation of *Spinning Room*, the camera in *Spinning Camera, Walking, Mike Cram Walking* (1971) keeps a clearer distance, revolving watchfully round a semi-darkened room with windows on three walls. At certain moments a man, identified as Mike Cram by the title, can be glimpsed walking round the perimeter of the room, quickly disappearing as the camera moves, echoing Cram's dispassionate activity. The light through the window blinds also flashes past as the camera spins, acting like a shutter exposing light within the chamber of a camera.

Couple and *Spinning Camera, Walking, Mike Cram Walking* are the only two extant films from a group of eight films that McCarthy made from 1966–71. The rest have been lost.[27] McCarthy also made several proposals for films that were never realized, including *Fly Film* (1974/75), a drawing showing two cameras on tripods, trained on two windows looking onto the street outside, which spin in arcs that eventually separate and rotate independently, shifting the resulting two-screen film from a binocular vision to two detached viewpoints flying round the room. The two cameras would eventually reach the surface of the wall and move through it, defying the barrier of physical matter.

In *Spinning Room*, conceived in the same year as *Spinning Camera, Walking, Mike Cram Walking* and five years after *Couple*, McCarthy's layers—mirror, screen, video, space—occur simultaneously, locating the installation's meaning firmly within the boundaries of "techne," or production. Its vertiginous movements are machinelike, echoing Krauss's description of Duchamp's spinning rotoreliefs of 1935, "busily enacting the images of industry: the flywheels, the turnscrews, the propellers."[28]

Duchamp's rotoreliefs are direct precursors of McCarthy's disorienting environment, situating it historically within what Baker describes as a "Baudelairean modernity with all of its subjective avatars—intoxication, vertigo, oblivion, diversion, distraction."[29] Baker quotes Benjamin's analysis of the cinema of this early period of around 1913 as creating a new temporal vision that erased the contemplative experience of painting. In film "no sooner has his eye grasped a scene than it is already changed. It cannot be arrested."[30] This produced, Baker goes on to argue, what Thomas Elsaesser described as "a model or metaphor for representing the body in relation to social environment" and "for conceptualizing the artwork as event rather than as object, no longer as products but as circuits of exchange for

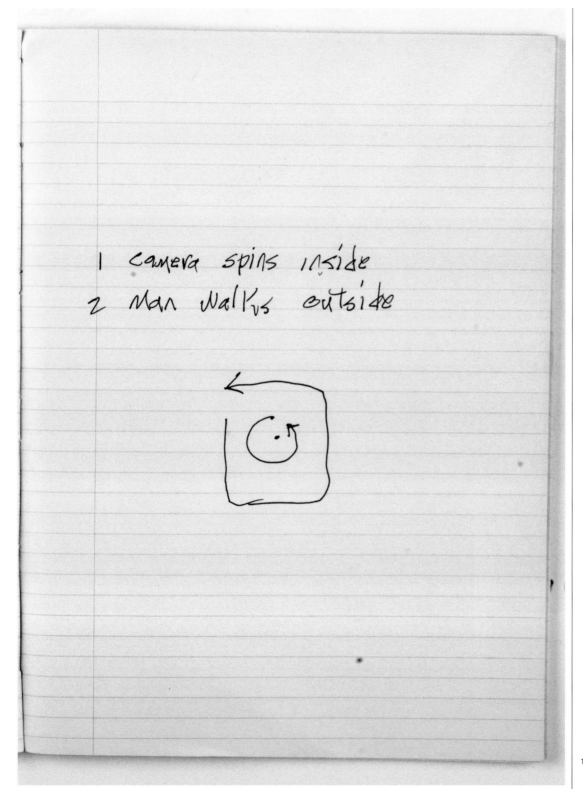

1 camera spins inside
2 man walks outside

Spin Walk Drawing, 1971. Ink on paper, 10 1/4 x 7 1/2 in. (26 x 19.1 cm). Collection of the artist; courtesy of Hauser & Wirth London/Zurich

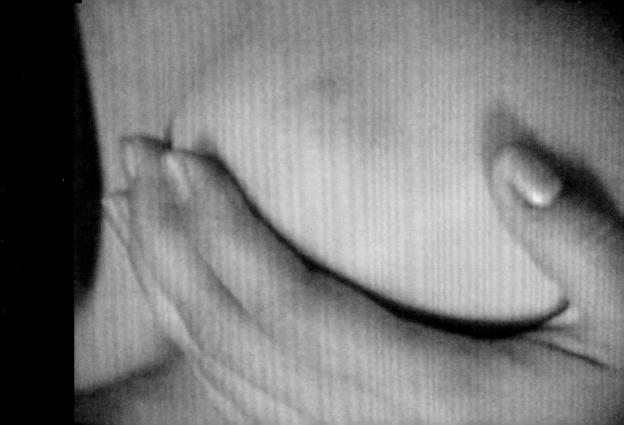

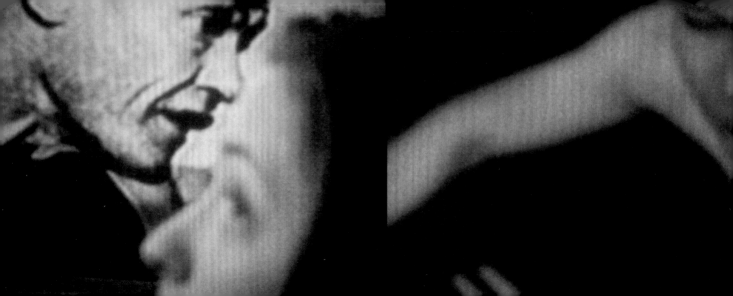

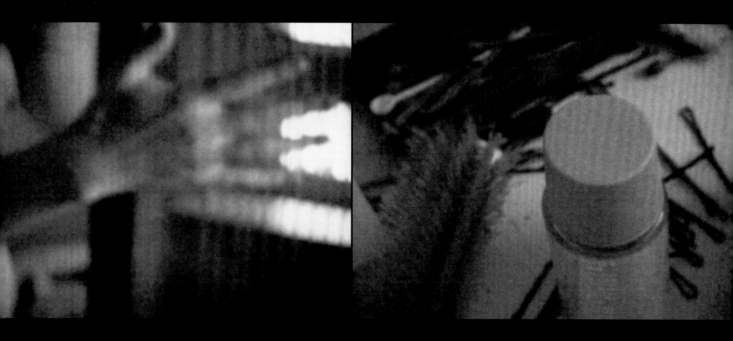

Stills from *Couple*, 1966. 16mm
film, black-and-white, silent;
15 minutes. Collection of the
artist; courtesy Hauser &
Wirth London/Zurich

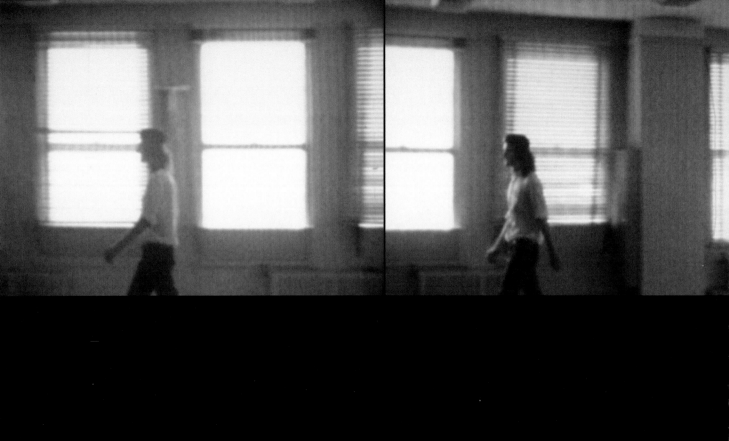

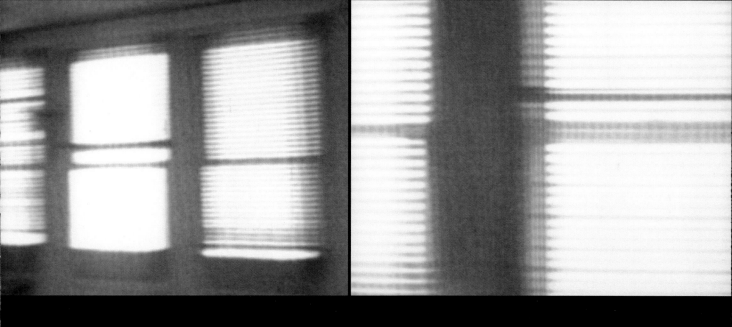

Stills from *Spinning Camera, Walking, Mike Cram Walking,* 1971. 16mm film, black-and-white, silent; 3 minutes. Collection of the artist; courtesy Hauser & Wirth London/Zurich

31. Ibid., p. 292

32. Baker, "The Split,"
p. 4.

33. Ibid., p. 6.

34. Ann Goldstein,
"Painting as
Architecture" in
*Mike Kelley and Paul
McCarthy: Collaborative
Works* (Toronto: Power
Plant Contemporary Art
Gallery, 2000), p. 39.

Roberto Matta, *The Unthinkable*,
1957. Oil on canvas, 78 x 118 in.
(198.1 x 299.7 cm). Collection of
Thomas Monahan

different energies and intensities."[31] Elsaesser's description resonates with *Spinning Room*, whose rotating images mimic Baker's nauseous distraction of early cinematic modernity.

Baker's arguments occur within a discussion of the work of Picabia, an artist whose works McCarthy has incorporated into several of his own. Picabia's perception of modernity as "a perpetual motion machine"[32] could equally be applied to *Spinning Room*, whose interior resembles a rotating projection machine gone wild. Picabia would have approved, judging by his statement that "cinema should give us vertigo...it should be...a promoter of intense sensations, surpassing the 'looping the loop' of airplanes and the pleasures of opium."[33]

The resonance of McCarthy's approach to the moving image with that of Picabia belies a broader relationship with Picabia's work. The large images moving across the mirrored screens of *Spinning Room* evoke McCarthy's collaborative project with Mike Kelley, *An Architecture Composed of the Paintings of Richard M. Powers and Francis Picabia* (1997). As the title indicates, the two artists created a complex architectural structure of halls and rooms whose interior walls were made of stretched canvases on which were air-brushed and hand-painted details of, in one room, Picabia's kitsch 1940s nudes, and in the next, four early abstract Picabia paintings. The two rooms were linked by labyrinthine hallways of surreal organic illustrations from 1950s book covers by the illustrator Richard M. Powers (whose influences included Roberto Matta). As Ann Goldstein observes, "the process of viewing *An Architecture* is thus a process of encounters and reversals and blurred distinctions: entering through the 'back' of a painting that itself is a wall that constructs an interior space; that wall and others like it, in turn, making up a theatrical set-like object within the white walls of museum architecture."[34]

Goldstein's description of *An Architecture* almost perfectly matches the environment of

Spinning Room. The imagery of the double-sided projection screens (further doubled by their reflection around the large mirrored walls) and the refusal of the screens to absorb the projected image fully into a screen surface confirms McCarthy's questioning of pictorial illusionism. The two-dimensionality of painting and the three-dimensionality of sculpture are collapsed into each other, through the volumetric space of architecture.

Spinning Room's planar composition resembles, in three dimensions, that of Matta's painting *The Unthinkable* (1957), in which four large free-standing screens are bombarded from both sides by imagery and movement emitting from a large revolving machine in the center of the interior space. Matta's composition, in which indeterminate green organic forms loom over the structure from the outside, as though attacking painting at its core, expresses a 1950s cold war–fuelled anxiety that was to erupt later in the neurotic spaces of the 1960s and early 1970s, as the theater of the Vietnam War was played out.

Matta's surreal composition was echoed in cinematic terms in the films of Stan VanDerBeek, whose work impressed McCarthy from his first encounter with it as a student. VanDerBeek, a graduate of Black Mountain College and a colleague of John Cage, Buckminster Fuller, and Kaprow, painted scenery and set designs for the American television show *Winky Dink and You*, before creating a series of animated painted films in the mid 1950s. *Science Friction* (1959) begins with spinning Duchampian discs and a collage of a head upside down and the right-side up. VanDerBeek expanded cinema space into three-dimensional space that prefigures *Spinning Room* in a series of "movie murals," projecting up to twenty films at a time around the room. In his *Movie Drome*, a domed construction built in 1963, he projected multiple films around the walls and ceiling, extending the conventional cinema screen format outward to cover the entire architectural interior.

VanDerBeek's utopian expanded film environment was prefigured in commercial terms by Walt

Disney, who in 1955, at the height of the cold war, opened Disneyland in Anaheim, California. Its childish world of fairy tales and children's stories writ large provided a nervous nation with an escapism that took two-dimensional cinematic fantasy into a vast three-dimensional realm. For McCarthy, Disneyland has always represented American corporate manipulation at its most insidious, in which infantilization operates as a form of social control. McCarthy adopts, exaggerates, and makes abject the language of Disney, shocking the viewer into a nightmarish alternative narrative in which limbs do not automatically reattach themselves, and objects threaten to spin out of control.

Mad House (2008) takes Disneyland references—the spinning teacup, surreal architecture, the scary ride—and saturates them with psychological anxiety and disorientation. A room with a window in each of its four walls revolves slowly on a low base. Inside the room, a separate revolving plat-form contains a single chair that, in turn, can also revolve. McCarthy's layering shifts from planarity to enclosure and movement. A viewer and the chair can remain still as both the platform and the room revolve. The chair can also be set to spin at

Stan VanDerBeek, *Science Friction*, 1959. Courtesy Anthology Film Archives

MAD HOUSE

chair stand still

Room spins

outside room is closed
still

chair spins

Room stands still

outside room appears
to spin

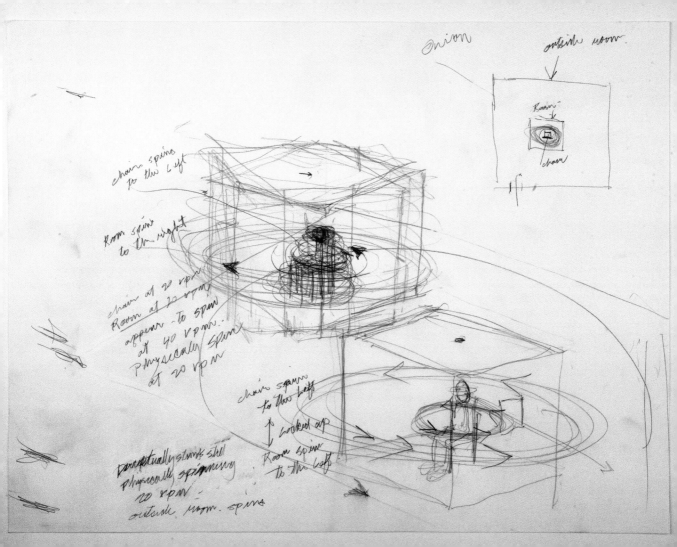

onion

outside room.

Room

chair

chair spins
to the left

Room spins
to the right

chair at 20 rpm
Room at 20 rpm
appear to spin
at 40 rpm.
physically spins
at 20 rpm

chair spins
to the left

looked at
Room spins
to the left

perceptually stands still
physically spinning
20 rpm
outside room spins

35. Baker, "The Split,"
p. 3.

36. Vidler, *Warped
Space*, pp. 40–41.

37. Robert Morris,
"Solecisms of
Sight: Spectacular
Speculations," *October*
103 (Winter 2003),
p. 32.

38. Adolf Loos,
*Ornament and Crime:
Selected Essays*
(Riverside, Calif.:
Ariadne Press, 1998).

the same time as the platform and room spin, in the same, or opposite, directions, creating three independent rotations moving in tandem with, or in opposition to, each other. The end result, when all are rotating together, relates to the layered planes of *Spinning Room*, but concentrates rotational movement in a spiral form, within which the body, rather than the camera (its prosthetic equivalent) occupies the center.

The vertiginous experience of *Mad House* recalls Picabia's words in 1913: "When I paint a race course, can you discern in my painting the cars madly spinning round the track? No. You see nothing but a confusing mass of colors, of forms that can seem strange, even disturbing...you will draw from my work the exaltation, the intoxication, of someone driving at two hundred kilometers an hour...I can render on canvas the very idea of movement, in such a way as to make you feel, taste and appreciate this frenzy of speed."[35]

The spinning interior of *Mad House*, and any figure sitting within it, is primarily observed through its windows. At the end of the nineteenth century, as Vidler reminds us, a number of psychological disorders related to space and alienation appeared, at the same moment that the city became transformed into a modern urban environment. The domestic interior became the focus of these disorders, which included vertigo and agoraphobia. As Vidler argues: "It is the apartment, the window, the street...that is identified as the instigator of the initial attacks; and whether or not these spaces are symbolic of something else...this space remains attached to the first fear...windows...were the physical frames...for an anxiety that was, if not caused by, then certainly figured through private and public space and its uncertain boundaries."[36]

Mad House arguably resembles the apartment, and the gallery space, the street. McCarthy collapses the two kinds of spaces into each other, creating the uncertain boundaries that Vidler describes. The edge where they meet is blurred by the triple rotation of the room's layers. The experience of vertigo exists in two forms: objective vertigo, the sensation of the

external world revolving around an individual; and subjective vertigo, where the individual is revolving in space. *Mad House* potentially induces both kinds, setting in circular motion both the space and the individual, sometimes rotating in opposite directions.

As Vidler points out, Freud suggested that the boundary of the window was, at the end of the nineteenth century, sexually fraught. The window, through which the prostitute traditionally plied her wares (a process known as *faire la fenêtre*), became a space of anxiety, a zone of displaced fantasy and danger, whose potential to erotically frame the female occupant of the room was matched only by the vertiginous possibility of falling out of it onto the ground below. Hitchcock based an entire film on the terror of such a possibility, constructing, as Morris argues, "an illusory, irrational, delusional and nauseating space," gendered as feminine, "dangerous and threatening...in which the male's rational power might become lost."[37] This gendered fear was reiterated in McCarthy and Mike Kelley's collaborative video piece *Heidi* (1992), in which the punishment of a female for her impurity is expressed through an architectural metaphor, in a clear citation of Adolf Loos's 1908 book *Ornament and Crime*. Heidi is instructed to read the sentence: "The white cube ejected the sick girl for getting ornamented with anti-ornament."[38]

The fearful trajectory of the ejected body brings to mind Yves Klein's *Saut dans le vide (Leap into the Void*, 1960), an important work for McCarthy, in which Klein appears to catapult himself from a ledge below a roof into the street, in a conceptual metaphor of immateriality. Klein's apparent leap from a window creates one void while reaching to occupy another. Whilst Klein transforms the erotic tension of the window into a frame for transcendence, in *Mad House* McCarthy uses rotation to underscore the window's role as a zone of displaced fantasy and danger. His structure renders the viewer insecure by the possibility of being ejected from the room by its tornado-like spinning.

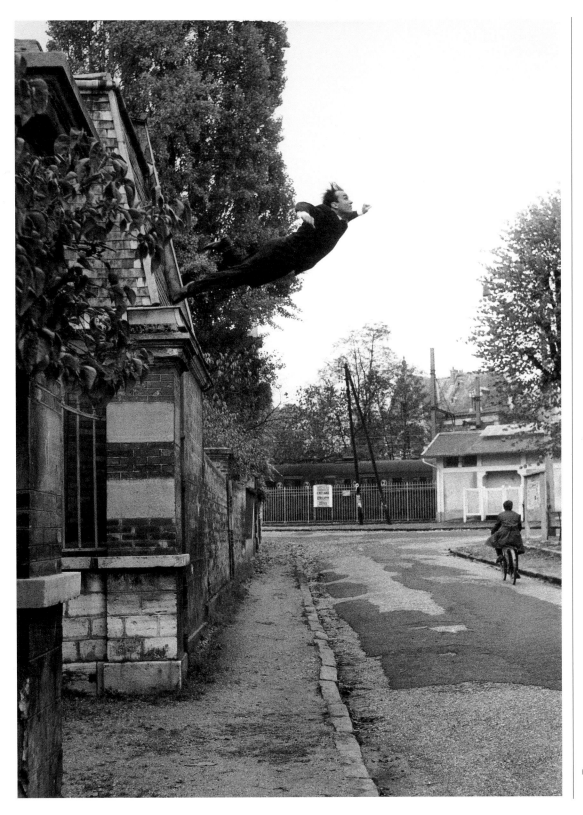

Yves Klein, Harry Shunk, and John Kender. *Leap into the Void*, 1960. Gelatin silver print, 10 3/16 x 7 7/8 in. (25.9 x 20 cm). The Metropolitan Museum of Art, New York; purchase, The Horace W. Goldsmith Foundation Gift through Joyce and Robert Menschel, 1992

39. Hayden Carruth, introduction to *Nausea* by Jean-Paul Sartre (1938; New York: New Directions, 1964), p. xii.

40. Paul McCarthy interview by Kristine Stiles, *Paul McCarthy* (London: Phaidon, 1996), p. 20.

41. Ibid., pp. 30-31.

Klein's staged photograph, made with photographer Harry Shunk, is directly related to his *Void Room* made two years earlier in 1958, depicting a completely empty gallery. As in *Leap into the Void*, *Void Room* confirms Klein's emptiness as metaphysical, in contrast to McCarthy's voids, which are existential. The oppressiveness of *Mad House* recalls Jean-Paul Sartre's existential novel *Nausea*, written in 1938, a year before the outbreak of the Second World War, in which the main character, Antoine Roquentin, struggles with the horror he feels at the meaningless of his existence. As Hayden Carruth writes in his introduction to the 1964 edition of *Nausea*: "When the Existentialist looks inside himself, what does he find? Nothing. Looking back beyond birth or forward beyond death, he sees the void; looking into his own center, thrusting aside all knowledge, all memory, all sensation, he sees the chasm of the ego, formless and inconceivable...and he is led to ask...why is there anything instead of nothing, why the world, the universe, rather than a void?... From this comes man's despair, but also, if he has courage, his existential integrity."[39]

Carruth's words are echoed by those of McCarthy: "I mistrust a lot of what has been conjured up in this culture. At one point I mistrusted reality completely. It occurred in 1971–72, when suddenly the experience of being confronted with my existence was overwhelming. And that experience lasted for over a year. I was confronted with nothingness, why was there anything, why was there something, an object, an inanimate or animate object?"[40]

The empty chair surrounded by windows in *Mad House* echoes Roquentin's sense of isolation: "Friday, 3:00 pm. A little more and I would have fallen into the lure of the mirror. I avoid it only to fall into that of the window....I see the future. It is there, poised over the street."[41] In *Mad House*, the viewer takes the position of Roquentin, sitting in a chair watching the activity in the gallery through the window. Yet McCarthy makes such flaneurship impossible. Within seconds of being seated, the viewer and/or room are spun round at speed, turning the outside world into a blur

Unidentified Artist, photograph from *Mon Paris* no. 15 (January 1937)

and the viewer into theater. McCarthy turns the voyeuristic structure of *Nausea* physically and metaphorically inside out. *Mad House* becomes a kind of claustrophobic stage, a metaphor of both the body and the mind, from whose agitated interior there appears to be no escape.

The possibility that this claustrophobic state might, in the end, be just a dream (or a nightmare) is suggested in McCarthy's

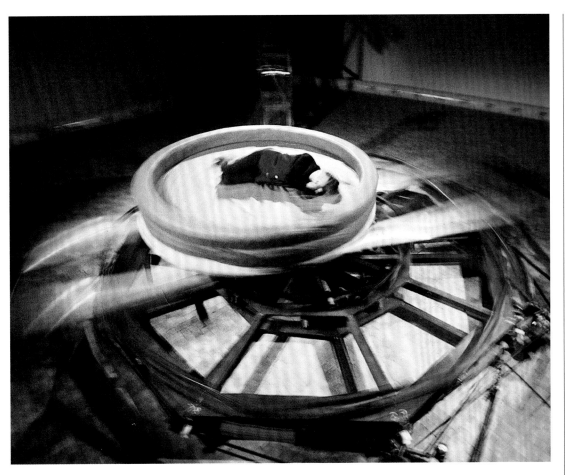

42. Daniel Birnbaum, "The Good The Bad and the Ugly: Porn, Photography and Picabia's Late Paintings," *Frieze*, issue 39, March–April 1998.

43. Bataille, quoted in Green, *Picasso*, p. 24.

44. Green, *Picasso*, p. 38.

installation *Picabia Love Bed/Picabia Dream Bed* (1999). Inspired by an erotic black-and-white photograph used by Picabia as a basis for his painting *la Femme et l'Idole* (1941), McCarthy renders the vertical, dominant female in the photograph, seen from the back dressed only in panties, horizontal and passive, sleeping in the middle of a circular spinning bed. McCarthy's mechanized eroticism echoes Daniel Birnbaum's argument regarding the hundred paintings of nude women that Picabia produced during the 1940s, whose uniformity created an "almost Warholian sense of mechanization."[42]

The relationship between architecture, painting, mechanization, the body and the vertiginous in both Picabia and McCarthy's work evokes Christopher Green's arguments regarding the relationship of architecture and vertigo in the paintings of Picasso, which Green reads through the writings of Bataille. For Bataille, as Green points out, architecture is not simply about the construction of buildings, but is "the face of authority in society...it is all that is set up by authority to put down the energies released from the interior of being."[43] As Green observes, Bataille regarded vertigo as a transgressive state that provides the possibility of such a release through the breaking of architecture's solidity, which "has to be shattered...When Bataille is concerned with the fall towards vertigo and death, he is almost always also concerned with architecture:...just as for Freud the death and life instincts behave interactively, so in Bataille the vertiginous is always interactively related to architecture, indeed *requires* the prohibitions of civilization. There is a continual, never checked oscillation between the vertiginous and the architectural; indeed, vertigo is created *by* architecture."[44]

Picabia Love Bed, Dream Bed, 1999 (installation view at Sammlung Hauser & Wirth, St. Gallen, Switzerland). Wood, metal, three digital camcorders, video transformer and antennas, video monitor, seven electric motors, remote controls, transformers, foam mattress, vinyl, and electric cables: frame, 17 ft. 7 in. x 31 ft. 2 in. (5.4 x 9.5 m); bed, 96 in. (243.8 cm), sides of equilateral triangle, 26 ft. (7.9 m) each. Collection of the artist; courtesy Hauser & Wirth London/Zurich

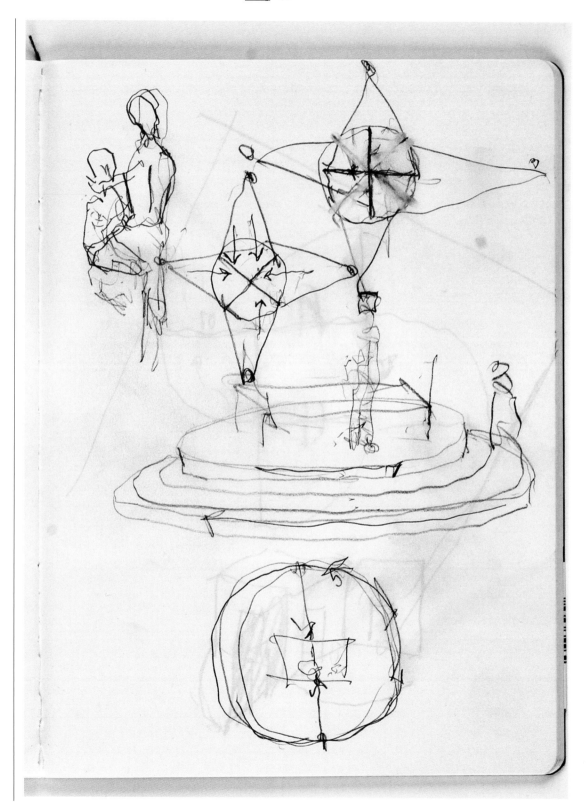

Picabia Love Bed Plan B Drawing, 2008. Graphite on paper, 10 x 7 1/2 in. (25.4 x 19.1 cm). Courtesy the artist and Hauser & Wirth London/Zurich

The implications of such vertiginousness are taken into erotic territory by McCarthy. Rotation and spinning operate similarly to his abject performative bodies, as a form of de-masculinization. As Amelia Jones argues, in McCarthy's performances "masculinity is performed as contingent and hysterical, not transcendent and originary."[45] The act of spinning conjures a similar hysteria, creating an irrational, out of control, and inherently feminine space. McCarthy's feminized spaces stand in for his own body, refusing to adopt the male dominant position in relation to architecture and opening up the viewer to the liberating possibility of losing control.

McCarthy's vertiginous architectural inversions thus articulate a central tenet of his work: an impulse toward the loss of self that "makes it possible for everyone to strike their own blows against architecture."[46] This impulse, according to Green, "give[s] culture the role of opening a space for vertiginous release within the social systems of prohibition and control that we call civilization."[47] In a recent exhibition curated by McCarthy of his own work and works by other artists important to him,[48] he included a photograph of Klein's *Leap into the Void*. It was not the familiar image of Klein leaping, but an unauthorized photograph, also taken by Shunk, of Klein, surrounded by a circle of people below, jumping down from the wall feet first. Just as he dismantles the illusion of Disneyland, the stability of architecture, or the psychological structures of male authority, McCarthy is drawn to the reality behind the illusion that Klein presents, drawing our attention back to the mechanism by which it is constructed in what could be read as an existential questioning of metaphysics. Similarly, in McCarthy's disorienting environments we become unsure of where the boundary between authority and freedom lies, and where the real world ends and fantasy begins. Dismantling, destruction, disorientation, and fear become the discourse of survival; a means with which to grapple with, if not to answer, deep existential questions of being.

45. Amelia Jones, "Paul McCarthy's Inside Out Body and the Desublimation of Masculinity," in *Paul McCarthy* (New York: New Museum of Contemporary Art), p. 129.

46. Ibid., p. 25.

47. Green, *Picasso*, p. 25.

48. This 2008 exhibition, *Paul McCarthy's Low Life Slow Life: Part I*, was held at the California College of the Arts Wattis Institute in San Francisco; the exhibition included works by McCarthy and other artists: John Altoon, Bob Arentz, Joseph Beuys, Stan Brakhage, Malcolm W. Browne, John Cage, Christo, Bruce Conner, Paul Cotton, Jay DeFeo, Marcel Duchamp, John heartfield, Wally Hedrick, Allan Kaprow, Yves Klein, Tetsumi Kudo, Yayoi Kusama, Lindy Guinness, Robert Mallary, Gustav Metzger, Allan Midgette, Henry Moore, Bruce Nauman, Yoko Ono, Al Payne, Raivo Puusemp, Tony Smith, Karlheinz Stockhausen, L. H. Strong, Stan VanDerBeek, Irby Walton, and Andy Warhol.

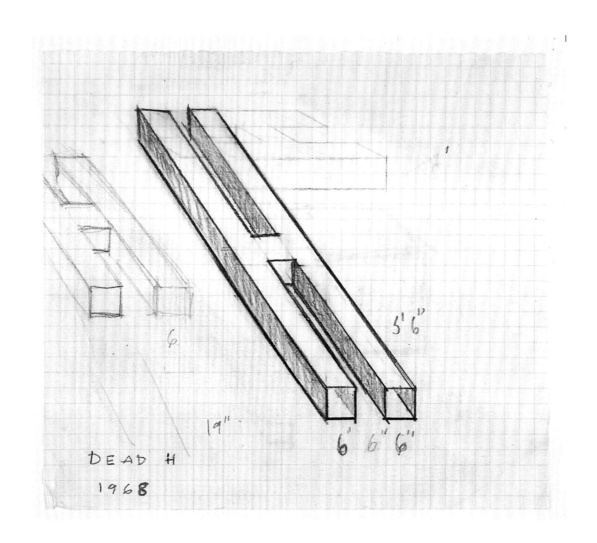

Dead H Drawing, 1968.
Graphite on paper, 7 1/2 x 8 1/2 in.
(19.1 x 21.6 cm). Collection of the
artist; courtesy Hauser & Wirth
London/Zurich

PAUL McCARTHY
in Conversation with Chrissie Iles

Chrissie Iles

In the exhibition, you're realizing a spinning room that you conceived in the early 1970s, when you first moved to Pasadena. Bruce Nauman also had a studio there then. Was there something about the environment that you and Nauman found yourselves in at that moment in Pasadena that drew out the engagement with architecture in both your work?

Paul McCarthy

No, I don't think so. But in the 1960s and 1970s, artists were making work about architecture—how pieces related to the wall, floor, ceiling. What is interesting is that a number of artists in California, including Nauman, were constructing an architecture that resembled a stage or film set.

Until the age of ten or twelve, I grew up in an odd suburb in Utah—a few streets in the middle of nowhere, a void. A California contractor had the idea to build a giant suburb where veterans could buy houses capitalizing on the GI loans; he built three streets then went bankrupt. The houses were all similar. At my parents' house, when you went out the back door, there were no other houses for miles, it was a vacant landscape. When you went out the front door you were staring at a street in the suburbs. It was like a film set, built only for the cameras.

I have been interested in box architecture, square rooms, hallways, and in underground tunnels, digging holes. It began when I was a kid. I have vivid memories of building huts with stacked rooms and digging tunnels. When I was in high school, I did drawings of square holes in the ground with people standing in front of them, holes as voids placed in landscapes where there was nothing, and a square hole in a flat surface. In 1966, I was painting on panels that I referred to as doors and windows. They were constructed like stage flats, or walls, and could be hooked together. In 1968, I made the *Dead H*, a sculpture in the shape of a capital *H* that lies flat on the floor, a dead sculpture. The shape of the capital *H* resembles a human. When you look through the open ends, which are six-inch square openings, you cannot see into the middle area between the legs. The straight corridors or hallways are an interior architecture too small to physically enter. In 1999, I made another *H*, *Dead H Crawl* [1968 and 1999] where the piece is large enough to crawl inside. This drastically changed the viewer's relationship to the interior space.

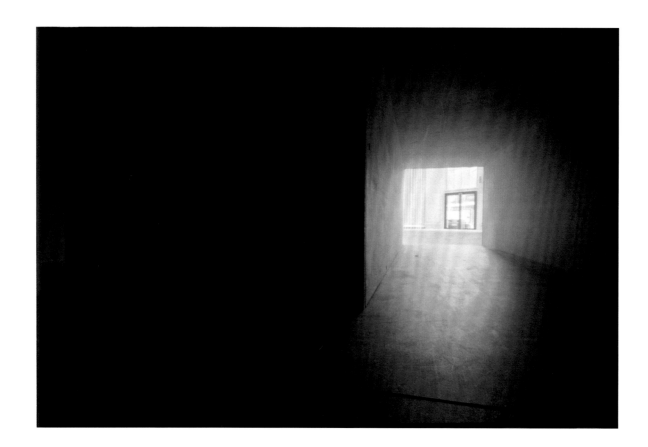

Dead H Crawl, 1968–99
(installation view at Sammlung
Hauser & Wirth, St. Gallen,
Switzerland). Medium-density
fiberboard, wood paneling,
steel L-metal, bolts, 24 in. x 72 in.
x 16 ft. (61 cm x 182.9 cm x 4.9 m)
overall. Friedrich Christian Flick
Collection, Berlin

Chrissie Iles

Why "dead"? Because of our inability to see the center?

Paul McCarthy

It lies on the ground motionless. *H* is for human. The space inside the sculpture is an intangible space, a void. I was making an object about its interior—the interior and the body, the interior and minimalism.

In 1967, I told friends I was going to spend the summer digging a trench, and at the same time I came up with the idea of digging competitions with people digging in teams. If there were three on each team, you would dig three days. The winners were the team with the deepest hole. It was an event, art as an event, an action. I wanted to have bleachers around the digging event. I was also making films at that time.

Chrissie Iles

What do you think the impact of looking at experimental films by filmmakers like Stan Brakhage and Bruce Conner at college had on you?

Paul McCarthy

It was a door opening up. It redefined art the same way Allan Kaprow and Happenings did. It was film as art, an alternative to traditional narrative film. At school they showed all of the Bruce Conner films. A week or so later I showed a film where I remade one of the Conner short films, but I changed the ending and put "A film by Paul McCarthy." It was a joke for those who had seen the Bruce Conner films. It was about the situation, using the situation—obvious plagiarism.

I began to make black paintings. The black door and window paintings were all about activity and action. My black paintings were painted with my hands and rags. I got on top of them; I put them flat on the ground. They were big and I had to go into the middle of them. They became stages or arenas. They were strong underneath. Painting them was physical. They were always made of Masonite, so that I could pour water on them. They were painted and washed, painted and washed. I would pour gasoline on them and set them on fire. I was burning and chopping at the surface of the painting, squirting them with water a type of performance. I knew Yves Klein's work, but I didn't know that Klein used water or fire. I only knew about the leap. But at that point I had not seen a photograph of the leap.

Chrissie Iles

Did the paintings still exist afterward? Or were they destroyed?

Paul McCarthy

I originally didn't try to destroy them. I burnt them to turn them black. I didn't think of it as ritual. It was simply the fastest way to turn them black, and I couldn't predict the outcome. The paintings went into storage until 1969 when I burnt some of them completely on my grandparents' property. I had intended to collect the ashes in a bottle, but I just left them there. I've never burnt anything since.

I still have two or three of the burnt paintings. Two of them have drawings of a woman from the film *The Pawnbroker* [1964]. In the film, Rod Steiger is a pawnbroker in New York who had been in the concentration camps. The paintings are from a scene where a young black woman strips in front of him behind the counter; she needs money. The scene was erotic and disturbing. At that time, I was taking images from films and magazines.

Chrissie Iles

You also saw Warhol's film *Lonesome Cowboys* [1968]. What was it about that film that resonated so much for you?

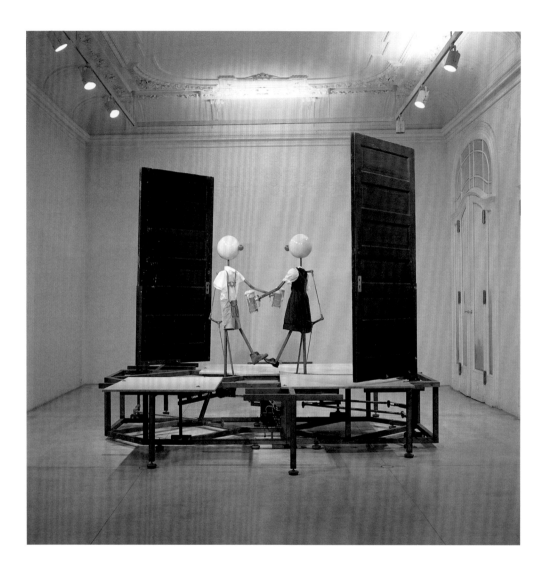

Bavarian Kick, 1987 (installation
view at Galerie Krinzinger,
Vienna). Wood, doors, metal,
motors, fiberglass, clothing,
12 ft. x 9 ft. 7 in. x 13 ft. 3 in. (3.7 x
2.9 x 4.1 m). Museum Moderner
Kunst Stiftung Ludwig, Vienna

Paul McCarthy

How it was made. A radical, subversive alternative to Hollywood. It is a perverse parody. It is fantasy play. It is obvious they are pretending. They have no interest in convincing the viewer that this all takes place in the 1800s. I am trying to build a Western town now; it will be a conglomerate of buildings attached together by doorways, the front door is the back door, the back door is the front door, the same facades at both ends repeating structures, two saloons, three general stores. It's a labyrinth of repeating buildings. There are no windows—architecture as subconscious. There is a saloon with a hole under the floor and an underground chamber.

Chrissie Iles

So it refers to the *H*.

Paul McCarthy

The way the town buildings are arranged makes a layout similar to an *H* shape, and the town is an interior labyrinth.

Chrissie Iles

And to the idea of oblivion?

Paul McCarthy

You were talking about oblivion yesterday. I was saying I made a list of oblivion events—something being destroyed, obliterated: the Branch Davidian compound in Waco, Texas; the MOVE house in Philadelphia; World War II Tokyo and Nagasaki in Japan; Dresden in Germany; the World Trade Center in New York; the Buddhist statues in Afghanistan. All acts of obliteration, domination and power. Obliteration as an act of transformation—obliteration and disappearance.

Chrissie Iles

Back to the void again.

Paul McCarthy

I made *Bang Bang Room* [1992], and the first time we turned it on and the walls opened up the piece became about something disappearing or vanishing. When the room is closed, the piece is a cube, when the walls open up, the cube shape goes away. The piece transforms. I also made *Mechanized Chalet* [1999], a Swiss house that comes apart then goes back together, as the transformation of architecture, a piece of kinetic architecture.

Chrissie Iles

What's the relationship between *Bang Bang Room* and *Mechanized Chalet*?

Paul McCarthy

When I made the drawings for *Bang Bang Room*, I also made a set of drawings for a house which would come apart. Walls would rise up in the air on cables, walls would move on tracks, and walls would fold down. The roof rotated and then went up on cables. The piece is technically more complex. After *Bang Bang Room*, I made *Mechanized Chalet*, which has been in storage for seven years. Underwater World [2004–5], which is part of the Pirate Project and a collaboration with Damon McCarthy, is the continuation of that mechanized architecture. I thought of *Underwater World* as an abstraction of a Hollywood film-world apparatus, moving rooms on gimbles. *Bang Bang Room* is also related to *Bavarian Kick* [1987] where two doors swing open and two figures come out, lift beer mugs and kick, like a town clock.

Chrissie Iles

Did the idea of mechanized architecture come out of the mechanized figure?

Paul McCarthy

I suppose so. I made *Colonial Tea Cup (Spinning Tea Cup)* [1987–94]. In this piece, what is normally an inanimate object, a tea cup, becomes animate. At one point I had the idea of making a big teapot that would talk. It was very Disney-esque; reality suddenly shifts, a teapot talks.

Chrissie Iles

Do you think the Disney association comes out of living in Los Angeles or does it have its roots much farther back in your childhood?

Paul McCarthy

I have been interested in Disneyland as sculpture—environmental sculpture—since the early 1980s. I am critical of, interested in, and influenced by Disneyland. "Breaking the dream" is a Walter Benjamin term and a Walt Disney term. But for Benjamin the term related to breaking the dream of conditioned reality. For Walt Disney it referred to breaking the constructed fantasy or the pleasure dream—the dream that does not question or confront the conditioned reality. I was also thinking about utopia. One thing that interests me is that Disneyland is surrounded by a mound, a hill; you enter through a gate and you're in another world, a dreamland. I grew up in Salt Lake City, which is also surrounded by mountains. The Mormon religion settled in this valley because it was isolated. I am interested in these two constructed dreamscapes—isolation and conditioning.

Someone once told me that a kid was in the back lot of Disneyland and saw a mascot squirrel or chipmunk with its mask off, smoking a cigarette. It terrified him. After that, the kid had nightmares, and the parents ended up suing Disneyland. The dream had been broken.

Chrissie Iles

It's interesting that Warhol never used Disney images, which are the most famous popular cultural icons of all.

Paul McCarthy

It's true. He was interested in media, movie culture, and commodities, but rarely in childhood fantasies.

Chrissie Iles

You, on the other hand, are looking at the reality of being dislocated as a child.

Paul McCarthy

But for me and my work, I am interested in the appropriation of the aesthetic of Disneyland and purposefully abstracting and distorting the images. As early as the late 1970s, I was interested in Disney and fascism, children and conditioning, authority and patriarchy—a natural, unnatural mix. Mike Kelley and I were both asked separately to be in a show in Vienna. We decided to work together. We made *HEIDI, Midlife Crisis Trauma Center and Negative Media Engram Abreaction Release Zone* [1992]. The house, the video set, is a schizophrenic structure. One side is a miniature Swiss mountain chalet, the other side is a replica of the facade of the *American Bar* by Adolf Loos—mountain bumpkin meets modernist reductive dogma. I brought Heidi. Mike brought Adolf Loos.

Before Heidi I began a photo piece that later became *Documents, a Straight Line from Hitler's Berlin to Walt Disney's Disneyland*. It was a collection of images from Hitler's Berlin through Bavaria, Paris, Vegas and finally Disneyland and Walt Disney. It also became a video, as a thousand images *Documents, Flicker Video* [2005].

Chrissie Iles

What's the relationship between what you've been describing and the destabilized domestic rooms?

Paul McCarthy

I worked for several years in the movie industry as a production still photographer, and I ended up on different sets. I was interested in sets and film constructions and contraptions/mechanisms used to produce an effect. I remember a mobile home with one side removed, which allowed the camera to look into the interior. The back wall had shelves, a refrigerator, a stove, pots and pans, and on the other side of the wall was a contraption of springs and levers designed to throw things off the shelves and tip over the refrigerator, simulating an earthquake. There was a facade of the normal and a contraption to disrupt it. I saw the fabricated room with an effect mechanism as an abstracted object. Like Disneyland, I am interested in Hollywood's contraptions and its production apparatus as sculpture.

The set for the piece *Bossy Burger* [1991] is an actual set from the television show *Family Affair*. It's a teenage hangout, called Bossy Burger, in the television show. The set was open on one side so the camera could look in, a typical form for television but I rearranged the set as an enclosed space, as a trap that Alfred E. Newman is in. I always imagine that on the outside of the set, in the dark, is a void. Alfred E. Newman is trapped in architecture, in a void. I thought of the swinging doors as a vagina, in/out doors (swinging doors or saloon doors).

Chrissie Iles

Bossy Burger is a body, like *Dead H*.

Paul McCarthy

The interior is an existence trap. At that time I was talking a lot about existence and the inability to escape. Sartre's *Nausea* had been an important book for me in the 1970s. The theatrical television architectural set is not a real house; it's a representation. It has an interior and an exterior. During this time, I began to talk about architecture as a contraption, kinetic architecture, which came directly from these mechanized television and film sets. At the same time, I was interested in Disney's mechanized environments; I was as interested in these as sculpture.

Chrissie Iles

How did *Spinning Room* evolve out of these ideas?

Paul McCarthy

In 1970, one of the first tapes I made was having someone video tape me spinning. I made a number of these spinning tapes over the next few years. I would spin for thirty minutes to sixty minutes, the length of the video tape. The reel-to-reel recording machine was on the floor. I was spinning as the tape reel spun. I made one tape where I held the camera, a portapack. The spinning room came out of these tapes and *Stand on the X*, the camera television pieces. I lost most of the spinning video tapes.

When I was at U.S.C. [University of Southern California], the school gave graduate students studios in a big building in downtown L.A. The videotape *Ma Bell* was done in that building. There was a stack of telephone books someone had left there. I had gallons of used motor oil, because I was making these paintings with motor oil, pouring oil onto big pieces of paper on the floor. During the performance *Ma Bell*, I covered each page of the telephone book with motor oil and cotton and told my friend, who was videotaping the action, not to include my head or my face. Later, in other video pieces, I would cover my face using ketchup or chocolate, then eventually I used a mask, an architecture over the head.

In the early 1970s I was making these pieces that were about in and out and ping-pong perception, mirror reflection, the view being disorienting and difficult to follow, pieces like the veil photograph, *ABC Room*, *Stand on the X*, and *Spinning Room*. *Spinning Room* couldn't be made at the time for a number

of reasons. The main one was the problem of transmitting the four video signals from the four spinning cameras to the four projectors.

Chrissie Iles

The motion of the revolving cameras in *Spinning Room* seems to echo that early piece, and to also have some relationship to Michael Snow's films, like *La Region Centrale,* where the camera is moved back and forth by the wind.

Paul McCarthy

That film was always important to me. I didn't see it until the late 1970s. I saw *Wave Length* in the early 1970s. I did see images of the spinning machine from *La Region Centrale* before I saw the film.

Chrissie Iles

What did you like about the film?

Paul McCarthy

The motion of spinning, the feeling of delirium, the multiple directions of spinning and the mechanical device that holds the camera. I made a work where I photographed a piece of broken mirror on the floor. I walked in a circle around the mirror. I moved around and closer to the mirror. I got closer and closer to the mirror. It's a series of photographs. As the camera gets closer and closer to the mirror (and I move around the mirror), the illusion is that the mirror is moving or turning. But the mirror is not turning. I go around the mirror in a spiral, a cone shape. The reflection in the mirror keeps changing as you're going around it. Eventually, the mirror and the reflection of the ceiling fills the whole view. You see only a reflection of the ceiling in the mirror.

Chrissie Iles

You don't see you in it?

Paul McCarthy

You never see the camera. You see the floor, a mirror, and the reflection of the ceiling.

Chrissie Iles

Will the mirrored walls of *Spinning Room* and the rotating cameras do something similar?

Paul McCarthy

*Spinning Roo*m remained a drawing until the last few years when Tom Whitson, who works with me, said he could make the piece. When we started working on it, I thought about using mirrors to reflect the projection. This could make the piece smaller, fitting it into a smaller room, and also I realized these mirrors around the projection screen added another layer of reflection, like an onion. The projection is another type of mirror. But I am not sure at the Whitney whether I will use the mirror walls; I have to wait to see. In 1970, I didn't realize how complex the layering of the feedback would be through the four rotating cameras and four projectors. It's really interesting the way it loops through the system and now with the digitizer, you can remove the feedback or keep the feedback or reverse the direction of the spin, the digitizer didn't exist in 1970.

Chrissie Iles

And now what about *Mad House*?

Paul McCarthy

When I made *Picabia Love Bed, Dream Bed* [1999] I had this idea of making a spinning ride for one person, a simulator device. You sit in a chair that can spin to the right or the left. The chair is in a small room that also can spin, separate from the chair, left or right. The room and chair would change directions and speeds through a program. The chair and the room could lock up rotating in the same direction or the chair and room can move separately in opposite directions. The ride constantly shifts your physical sensations of spinning and your perception of spinning. My plan is to have *Mad House* licensed as a ride. I want people to be able to experience the ride.

—This converation took place with the artist at his studio in Altadena, California, on January 17–18, 2008.

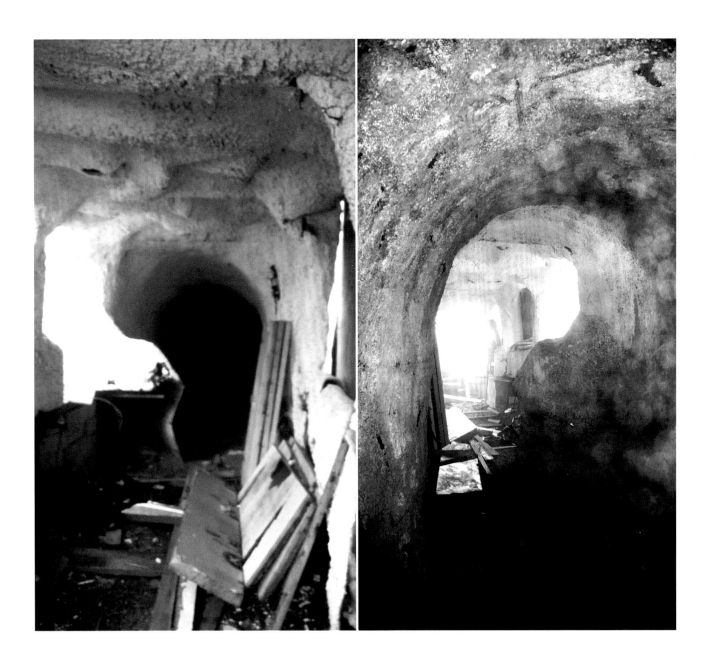

Works in the Exhibition

Couple, 1966
16mm film, black-and-white, silent; 15 minutes
Collection of the artist; courtesy Hauser & Wirth London/Zurich

Spinning, Edit #1, 1970
Video, black-and-white, sound; 2 minutes
Collection of the artist; courtesy Hauser & Wirth London/Zurich

Spinning Room, conceived 1970, created 2008
Aluminum, wood, Servo motors, vinyl rear projection screens, video projectors, electric motor,
sensors, electrical components, show control, video equipment, dimensions variable
Collection of the artist; courtesy Hauser & Wirth London/Zurich

The Veil, 1970
Chromogenic color print
Collection of the artist; courtesy Hauser & Wirth London/Zurich

May 1, 1971, 1971
Slide projection
Collection of the artist; courtesy Hauser & Wirth London/Zurich

Meditating Financial Federation Drawing, 1971
Ink on paper, 11 x 8 1/2 in. (27.9 x 21.6 cm)
Collection of the artist; Hauser & Wirth London/Zurich

Mirror Photograph—Spiral Cone Shape, 1971
Sixteen gelatin silver prints
Collection of the artist; courtesy Hauser & Wirth London/Zurich

Spin Walk Drawing, 1971
Ink on paper, 7 1/2 x 10 1/4 in. (19.1 x 26 cm)
Collection of the artist; courtesy Hauser & Wirth London/Zurich

Spinning Camera, Walking, Mike Cram Walking, 1971
16mm film, black-and-white, silent; 3 minutes
Collection of the artist; courtesy Hauser & Wirth London/Zurich

Upside Down Chair, 1971
Wood, chair, rope, and building, dimensions variable
Collection of the artist; courtesy Hauser & Wirth London/Zurich

Bang Bang Room, 1992
Wood, steel, motors, linoleum, and wallpaper, 8 ft. 2 in. x 9 ft. 6 in. x 9 ft. 6 in.
(2.5 x 2.9 x 2.9 cm) closed; 8 ft. 2 in. x 28 ft. 6 in. x 28 ft. 6 in. (2.5 x 8.7 x 8.7 m) open
Collection Fondazione Sandretto Re Rebaudengo, Turin

Mad House, conceived 1999, created 2008
Steel, Servo motors, industrial motion controller, electrical components,
sensors, plywood, and rubber, dimensions variable
Collection of the artist; courtesy Hauser & Wirth London/Zurich

Santa's Village Cave; In and Out, 2005–8
Two chromogenic color prints, 40 1/4 x 72 in. (102.2 x 182.9 cm) each
Collection of the artist; courtesy Hauser & Wirth London/Zurich

As of April 24, 2008

Seth Fogelman
Carter Foster
Samuel Franks
Murlin Frederick
Annie French
Donald Garlington
Larissa Gentile
Stacey Goergen
Jennie Goldstein
Meghan Greene
Emily Grillo
Peter Guss
Kate Hahm
Kiowa Hammons
Whitney Harris
Barbara Haskell
K. Michael Hays
Matthew Heffernan
Dina Helal
Claire Henry
Brad Henslee
Tove Hermanson
Carlos Hernandez
Ann Holcomb
Nicholas S. Holmes
Tracy Hook
Abigail Hoover
Brooke Horne
Marisa Horowitz
Kat Howard
Henriette Huldisch
Wycliffe Husbands
Beth A. Huseman
Chrissie Iles
Carlos Jacobo
Bernard Johnson
Kate Johnson
Diana Kamin
Amanda Kesner
Chris Ketchie
David Kiehl
Anna Knoell
Nina Kong
Tom Kraft
Emily Krell
Margaret Krug
Tina Kukielski
Diana Lada
Diana Lee
Sang Soo Lee
Kristen Leipert
Monica Leon
Vickie Leung
Jeffrey Levine
David Little
Kelley Loftus
Sarah Lookofsky
Elizabeth Lovero
George Lowhar
Doug Madill
Carol Mancusi-Ungaro
Gemma Mangione
Joseph Mannino
Heather Maxson
Jessica McCarthy

Julia McKenzie
Julie McKim
Sandra Meadows
Graham Miles
Sarah Milestone
Dana Miller
David Miller
Ashley Mohr
Shamim M. Momin
Matt Moon
Josué Morales
Victor Moscoso
Colin Newton
Sasha Nicholas
Carlos Noboa
Kisha Noel
Jackie Nolen
Thomas Nunes
Brianna O'Brien
Nelson Ortiz
Nicholas Parish
Christiane Paul
Sally Petrick
Angelo Pikoulas
Dana Pinckney
Berit Potter
Kathryn Potts
Linda Priest
Vincent Punch
Stina Puotinen
Christy Putnam
Catie Rachel
Jessica Ragusa
Jeremiah Reeves
Maggie Ress
Emanuel Riley
Felix Rivera
Jeffrey Robinson
Georgianna Rodriguez
Gina Rogak
Justin Romeo
Joshua Rosenblatt
Amy Roth
Carol Rusk
Doris Sabater
Angelina Salerno
Karla Salguero
Rafael Santiago
Galina Sapozhnikova
Lynn Schatz
Gretchen Scott
Julie Seigel
David Selimoski
Hadley Seward
Joshua Shapiro
Erin Silva
Matt Skopek
Joel Snyder
Michele Snyder
Stephen Soba
Leily Soleimani
Jessica Sonders
Barbi Spieler
Carrie Springer
Chrystie Stade

Mark Steigelman
Minerva Stella
Nicole Stiffle
Hillary Strong
Emilie Sullivan
Elisabeth Sussman
Mary Anne Talotta
Kean Tan
Ellen Tepfer
Phyllis Thorpe
Kristin Todd
Robert Tofolo
James Tomasello
Limor Tomer
Alexis Tragos
Beth Turk
Ray Vega
Snigdha Verma
Eric Vermilion
Jessica Vodofsky
Cecil Weekes
Adam D. Weinberg
Margie Weinstein
Allison Weisberg
Adam Welch
Alexandra Wheeler
John Williams
Natalee Williams
Nicholas Wise
Rachel de W. Wixom
Sarah Zilinski